DRAWN *from* LIFE

First published in 2017 by Hardie Grant Books

Hardie Grant Books (Australia)
Ground Floor, Building 1
658 Church St
Melbourne, VIC 3121
hardiegrant.com.au

Hardie Grant Books (UK)
52-54 Southwark Street
London SE1 1UN
hardiegrant.co.uk

10 9 8 7 6 5 4 3 2 1

ISBN: 978-1-78488-108-5

Publisher: Mark Searle
Editorial Director: Isheeta Mustafi
Commissioning Editor: Alison Morris
Editor: Nick Jones
Junior Editor: Abbie Sharman
Art Director: Michelle Rowlandson
Layout: Agata Rybicka

Image Credits
Front cover (clockwise from top left):
Endre Penovác, Ekaterina Koroleva, Agata Marszalek, Jylian Gustlin, Julian Landini,
Emily Isabella, Paul Heaston, María Cerezo

Back cover (top to bottom):
Julian Landini, Mark Tennant

DRAWN *from* LIFE

HELEN BIRCH

hardie grant books

Flipping through this book

In addition to the contents listing opposite, we have included artist and visual indexes to help you dip in and out of this book. Use these to find specific information or sketches quickly.

VISUAL INDEX

Because this book is as much about visual inspiration as it is about technique, we have also included a visual index on **pages 6–9**. If you are trying to find an image you have already seen in the book, or are looking for a specific style, colour or background, use this to take you straight to the right page. Page numbers are given on the thumbnail of each sketch. Please note that where more than one drawing is included in an entry, only one is included in this index.

ARTIST INDEX

If you'd prefer to search for images via the artists, an index listing artists alphabetically by last name is on **pages 204–205**. Here you will find a full list of the pages their art appears on, and also blog or website details if you'd like to check out more work.

EKATERINA KOROLEVA
JOUER
Medium: Ink, watercolour, digital

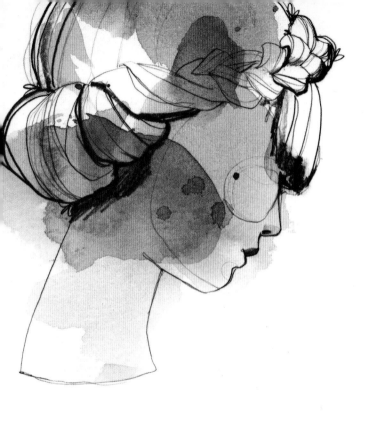

What is drawn from life?

The term 'drawn from life' is most often applied to the type of drawing that takes place in a life room. We can all picture it: a model surrounded by students standing at easels, drawing 'properly', studiously and well.

If you're lucky enough to have attended one of these classes, you'll know that how we imagine them to be is only partly true. These aren't hallowed spaces; they're places to observe the figure anew, to learn new techniques, and to gain confidence in interpreting the human form. Many of the drawings in this book have been made in such a space. Sessions like these are widely available to all, with models clothed or unclothed.

Figure drawing can, of course, take place outside of the life room, too. It's possible to draw others while travelling, sitting on the beach, in cafés or restaurants, or at home. An obvious solution is the self-portrait – the model always turns up! Carrying a sketchbook and the minimum of drawing equipment makes it possible anywhere – as a longer pose or as a fleeting idea.

Don't be too purist about how to interpret drawing from life. If you want to draw from photographs, do. Just remember that a photograph has flattened tone, changed colours and warped perspective. Seeing the figure directly ensures a more personal interpretation.

To draw from life is to participate in a centuries-old artistic tradition. Drawing from life doesn't necessarily mean concentrating on likeness; it might be how the body arranges itself, or the impression it seems to leave when moving. Use this book to try a variety of approaches to the figure – large scale and small, traditional and experimental, sophisticated and humble.

Helen Birch

DWAYNE BELL
ALEX
Medium: Pen, digital

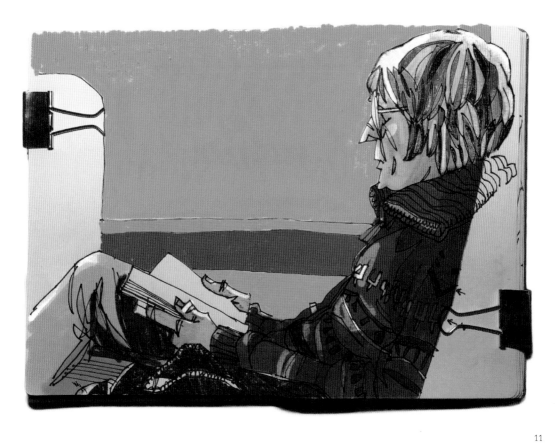

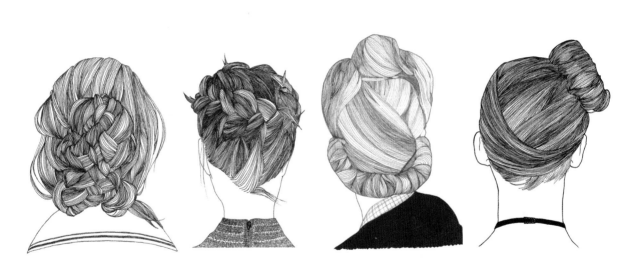

The sketches

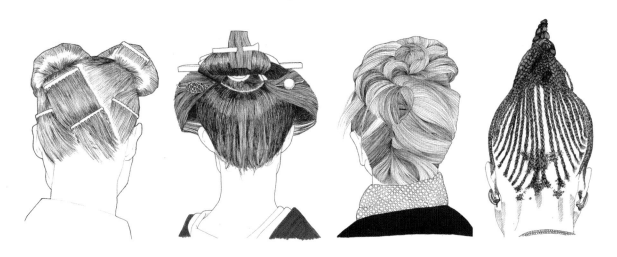

MARIA GIL ULLDEMOLINS
LIZA, BRIDGETT, KATHERINA, STELLA, BUNS AND
COMBS, GEISHA'S THOUGHTS, REBECCA, BIANCA
Medium: Fineliner pen, Indian ink

Mapping time

MARK HORST

Presented side by side like this, we're able to compare two of Horst's drawings made from the same model in the same location. It enables us to see how drawing experiments on the same basic framework can alter the appearance of a drawing. It's important to know that Horst is a painter. He's used these drawings to think, to play, alter and plan for those paintings. They're like visual notes to himself.

The setting is relatively simple – a corner, a chair, a model. Paired together like this, the drawings are reminiscent of storyboards (a set of images for a film or animation which aid visualisation). The scene is sidelit from the right. Shadow evidence makes clear this is the case. It's more likely that this is natural light. The subtle shift in the shadows' geometric shape documents the fleeting passing of time.

Horst's depiction of the model suggests that he's used lens-based media – not only to distill time and capture nuanced movement, but to enable him to get the basic outline of the figure down pat. The artist has blocked in the forms with Conté crayon and then roughly defined some of the contour edges of the negative spaces with pastel. The outlines have a semi-traced quality to them. This makes them seem like notations on old-process photographic contact sheets. A technique to enable this kind of drawing might be tracing the projection of a chosen image via a digital projector.

Consider an overhead projector (OHP). Photocopy your chosen image onto acetate before projecting and then tracing it.

J. L. WITH HAND ON HEAD, J. L. WITH HANDS TOGETHER
Medium: Conté, pastel

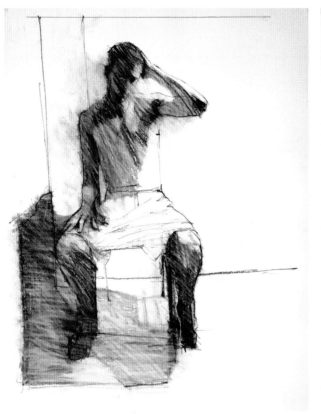

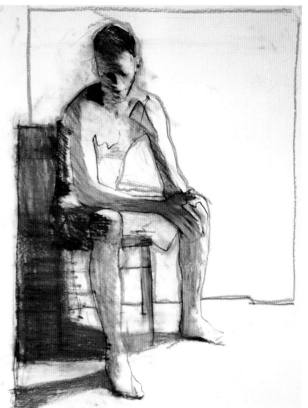

15

Using the edges

ANN PAJUVÄLI

The initial impact of this drawing is in its unusual composition. Its main elements – a crouching figure and a low table – are placed unusually; neither of them fits within the usual boundaries. They go off the edges of the paper. Given the title of the drawing, this slipping out of the frame, this becoming periphery, makes compositional sense.

Composition is an important part of any successful drawing. To compose an image is to decide how to arrange things within the space available – usually the sheet of paper selected. The arrangement and combination of those elements or ingredients can come about as a direct observation of what the artist sees – the figure and what surrounds it, a record of things 'as is' – or, as here, manipulated after the observational stages of the drawing have taken place. The dynamic of this piece depends upon the elements of the drawing being cut through before being reconstructed. Photoshop has been used here. Simple cut-and-paste techniques would work just as well.

The figure has been drawn with graphite pencil, worked up from a model and the artist's reference photo of the model. Mark-making ranges from grey outline, to gentle shading for the figure, quick back-and-forth parallel lines for the shorts, and carefully observed lines for the fabric check. Multi-directional strokes of black marker pen suggest rug texture; a black squiggle suggests hair at the nape of the figure's neck. The black and white, organic form of the figure is balanced by the coloured marker-drawn, geometric form of the table, plus Photoshop cut-throughs of the rug. The random tubes and sticks add the final compositional detail.

It's actually very hard to draw like this. Observing and drawing is usually a centre-of-our-focus activity, and therefore our drawing ends up centred on the paper.

I THINK I STOLE YOUR MEMORY
Medium: Graphite pencil, coloured pencil, coloured marker, Photoshop

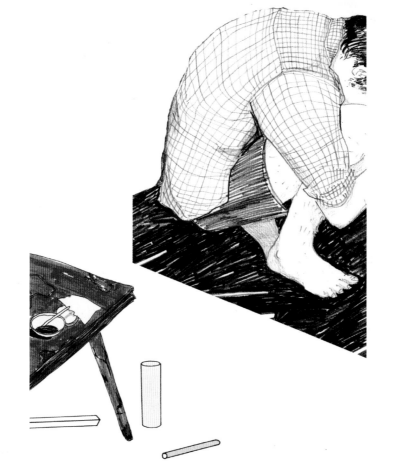

Researching a pose

CRAWFURD ADAMSON

It can be a good idea to have a variety of starting points as regards why, or how, one might draw the figure. We can't always rely on a life drawing class to provide a pose we're genuinely interested in. The class you might attend will probably have a tutor and peers who are willing to hear new ideas that you might have.

Like Adamson, consider using classical mythology to base a drawing on. Adamson has elected to develop an idea using one of the three female characters known as the Fates, or Moirai. Similarly, consider letting mythological (or historical) stories help you to decide on possible poses that might construct a story or narrative. Doing some research will provide a wealth of images. Artists have often used the characters and stories found in classical mythology as a prompt. Any trip to a major art gallery will provide you with many examples of art using this subject matter, whether as painting, sculpture or drawing.

As a figurative painter, Adamson does studies like this to enable him to make decisions about what gesture a character might make, to develop interesting angles, or to work out where and how they might be placed in the painting's final composition.

An interesting part of this drawing is the original position of the elbow. The artist made a decision to exaggerate the length of the arm, to supersize it so that the gesture made by the hand is scaled up and made much more significant. The soft lead of a 6B pencil means that nuances of pressure give a range of tones from black through pale grey. The lines search for the right position and reveal the workings out.

STUDY FOR TRIUMVIRATE
Medium: Graphite pencil

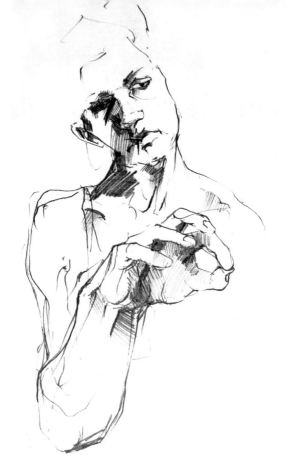

Using geometric shapes

JYLIAN GUSTLIN

Urgency can be important when capturing a figure, even when that person is a professional model, as here. Some poses are difficult for a model to maintain. Look at how the legs are bent at either side. Consider how difficult it is to be comfortable like that, taking all that upper body weight on the wrists and hands.

Making the decision to get marks down quickly can help to capture a pose. Here, the artist has quickly located a basic shape suggested by the figure. The top of a triangle is found in the shoulders and, at the spine's base, its downward point. Look how the olive-hued pastel has been used to accentuate and locate the backwards-leaning figure's main shape. The curves of the triangle's sides seem to take up that weight, to anchor the model to the paper and give her something to lean against.

Another geometric form makes up the head of the figure, albeit a roughly rendered one. This almost angrily scribbled charcoal circle manages to locate the right-tilting head of the model. It captures the only point of temporary ease in the whole pose. Its blackness is balanced, diagonally opposite, by the base of the model's foot, which is closer to the viewer.

Pencil line is used to draw in the more complex and detailed parts of the pose – the foreshortening of the model's left thigh, the grasping hand, the big toe. Combined with the layering and smudging of the pastel and charcoal, it has been handled without fuss. The pose has been captured before the moment is lost.

DRAWING 3
Medium: Charcoal, pastel, pencil

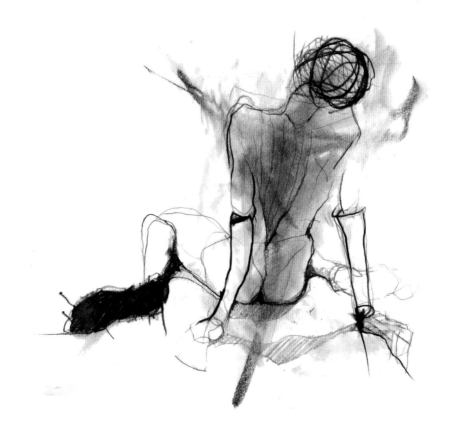

Monochrome studies

HELEN STRÖM

Ballpoint pen drawing perhaps isn't taken as seriously as works done in more traditional media. The reason for this might be because these pens are so easy to obtain – we consider them cheap and disposable. How many of us use them to doodle with while on the phone, scribble in magazines or on newspapers with them, or remember them from school when many a notebook cover was decorated with them? Just as then, picking up a pen and completing a drawing is still a habit we can maintain.

Having a decent sketchbook (this one is a Moleskine) is a real encouragement. Ironically, cheap pens are, too. They're easy to come by, we can put them to one side if we don't like the mark they make – the line quality might be too scratchy or inconsistent, too stop and start, too thick and thin – and pick up another. Ström has exploited the line abilities of her pen by varying pressure (particularly for hair and facial features) and using cross-hatching to create tone.

There are a limited number of ballpoint pen colours available. Ström has elected to use the colour red – something we often associate with highlighted comments in those aforementioned schoolbooks. It's a bold colour to choose. Her drawing of these men utilises the whole double-page spread of the sketchbook. Because it's composed of multiple studies that overlap, in monochrome (one colour), it reads as one drawing. She's added watercolour touches (ballpoint ink is oil-based and therefore waterproof) – an orange-red on the lapels, and a more scarlet red elsewhere to fill out the drawing and maintain the red theme.

Sketches like this are unlikely to be formally posed. They are more likely to be informal opportunities that arise while out and about.

MEN IN RED
Medium: Pen, watercolour

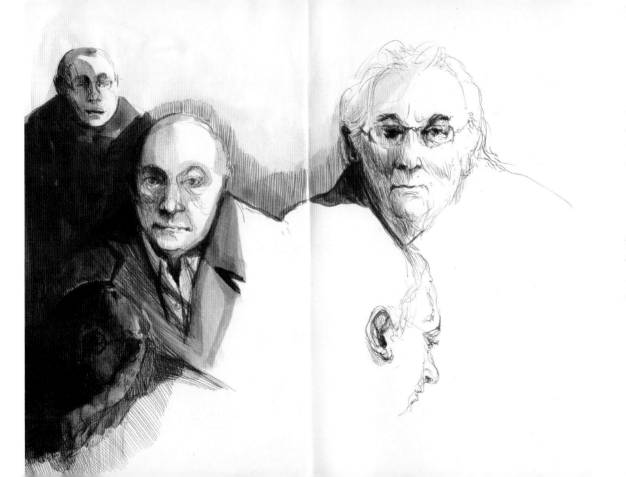

Suggesting movement

DEREK OVERFIELD

Overfield is a figurative artist who draws and paints the figure exclusively. Much of the influence for his work comes from the sculptural forms of old Greek and Roman masters.

Deciding to use a low vantage point from which to make an observational figure drawing tends to make the subject appear larger, more dramatic. It raises them up, puts them on an imagined pedestal, makes them seem monumental, and makes you, the viewer, feel smaller. This is a visual trick often used in classical works – think of statues or large paintings, where size and magnificence are important parts of a work's meaning and message.

The dramatic vantage point is balanced by a strong composition. The hands take centre stage, communicating something through gesticulation and suggested movement. The artist uses a contemporary method to observe and record these moments – a video camera, to capture the model between poses, slowing the movement down, selecting captivating moments to draw from.

Working from a combination of life and film, utilising mass gesture and contour techniques, the artist has created a drawing that is subtle yet dramatic at the same time. Grey chalk maps movement, and black charcoal provides outline. The work is spontaneous and yet meticulously planned. Importantly, it is not overworked. At 23 × 30 cm (9 × 12 in), this relatively small drawing carries a dramatic weight. It successfully resides in a private collection.

DRAWING 286
Medium: Charcoal, chalk pastel

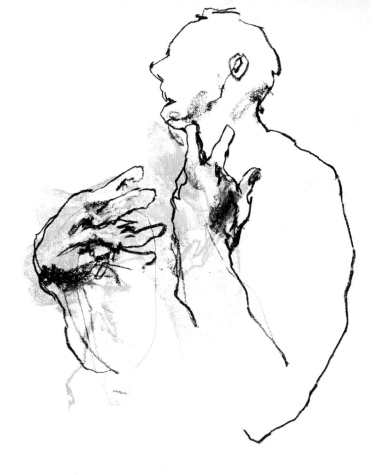

Informal practice

HEIDI BURTON

This drawing within a drawing shows us how Burton uses her Moleskine sketchbook. It also demonstrates how informal drawing from life can be. The artist has used herself as the model and drawn in surroundings where she feels relaxed and at home, in this instance her parents' house. However, this informal approach to drawing from the figure is as serious in its intent to study human form as other works in this book.

'I enjoy drawing people, but more specifically hands and feet because not only are they expressive and unique, but often avoided because they prove hard to draw,' comments Burton. 'I set myself the challenge of learning to draw them by practising drawing my own hands and feet relentlessly.'

The beauty of carrying a portable drawing kit – here a sketchbook and 3B pencil – and of a quality you know and trust, is that you are more likely to find moments like this.

The Moleskine sketchbook is a popular piece of a drawing kit for artists. There are practical reasons for this: its characteristically curved corners do not become dog-eared, and the smooth, cream paper is excellent to draw on using a range of materials; the pages are stitch-bound, which allows them to lie flat when open; the black oilcloth cover, resembling leather, travels well; and details such as a ribbon bookmark, a pocket on the inside back cover, and a rubber band to hold the cover closed when not in use, are useful extras. Its paper is acid-free, meaning work can be stored safely. Many artists keep shelves full of these sketchbooks.

LEGS ON MARIMEKKO
Medium: Pencil

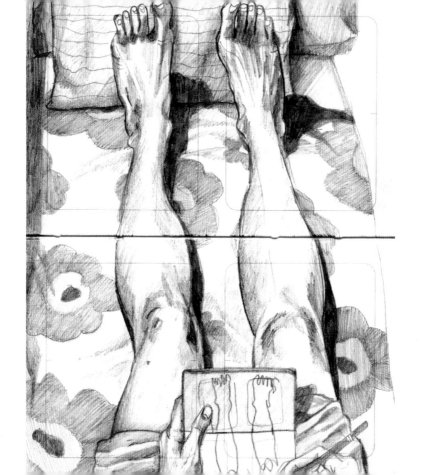

Choosing a location

JYLIAN GUSTLIN

This drawing was sketched on a public beach. *En plein air* – meaning 'open (in full) air' – is more often applied to painting outdoors, but can be applied here, too. This method of drawing the figure contrasts with the other poses in the book. Nothing is predetermined or formal. The artist relies on what she finds.

Selecting locations where you're likely to see the human form in a more natural state is a good idea. The beach is an ideal scenario. Take your drawing materials to places where others are likely to be relaxed, where the positions they maintain are going to be varied, but held long enough to get some observational drawing done. The main challenge when working outside is one's own preparation – what equipment to take, where to set up, environmental conditions and perhaps onlookers.

What method you select to draw your subject will be influenced by what they might be doing (or about to do), how far away they are, and maybe how aware of you they are. The lines here are flowing, continuous, searching. Some are more defined than others. Areas of tone have been hastily drawn and smudged in.

One could play safe when out and about and draw with the basics – pencil on paper. This artist has used charcoal and pastel, too. The drawing is richer as a result. These materials can be purchased in pencil as well as in stick form, which makes it easy to keep yourself, your drawing kit and your work clean and transportable.

DRAWING 4
Medium: Charcoal, pastel, pencil

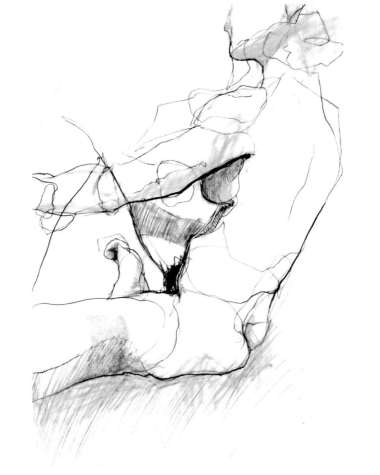

(Re)arranging figures

DEANNA STAFFO

Staffo is an illustrator and lecturer. This image was drawn during an outdoor sketch break in a class she was teaching. Watching the students hard at work inspired her to pull out her sketchbook and pencil. As a successful professional, Staffo knows that practising is an important factor in the ongoing upkeep of her skills. Practising alongside students sets a good example.

Because she was busy advising others, Staffo's own time was limited. She drew the elements on the page separately but composed the page so that it still feels harmonious. This combining of separate parts makes a composite drawing. She's cleverly arranged the drawing of her students and their environment to suggest their relative positions to one another. Only the scale of the two figures in the left corner makes us guess the arrangement might be partly manufactured.

Staffo has used some clever devices to portray depth in her drawing. The students in the foreground are larger. They're directly in front of her. Their shoulder cut-off line might signify the top edge of the artist's sketchbook as she peers over it. Moving diagonally to the right, a cross-legged student sits in front of a foreshortened raised area. The shape leads our eye up the page and over to the figure on the bench. As the figures recede, they reduce in size.

As an experiment, temporarily block out the figures in the left-hand corner. Where might you place them so their relative scale seems to better fit the scene?

SKETCHING
Medium: Graphite pencil

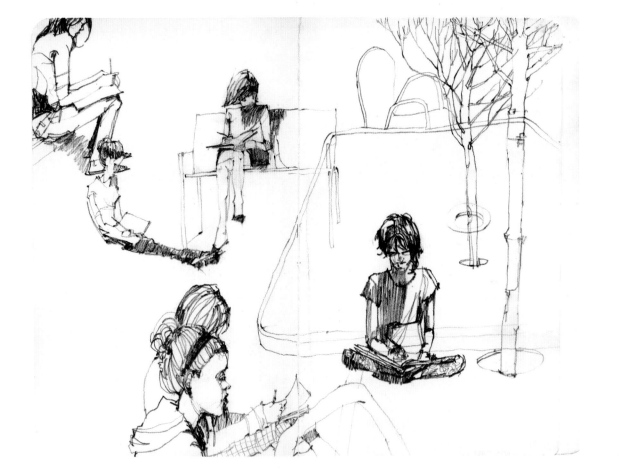

Conté crayon

HARRY ALLY

This female model has been sketched using Conté crayons. These come in a square stick form measuring 63 mm long × 6 mm square (2½ in long × ¼ in square). They are sometimes called hard pastels. Their mix of graphite, kaolin clay and natural pigments is firmer and waxier than the softer chalk pastels. This means they can be easily snapped to a length you might want to draw with and produce less dust than charcoal and chalk. (This might be important if you're sketching in an art gallery or public space.)

This drawing has been completed at an easel in a life drawing room. The artist has elected to use Conté crayon not because he's avoiding making a mess, but because of the versatility of the medium. Dragging Conté crayons flat on their sides, parallel to the paper, is good for large mark-making and shading, or laying colour down quickly. For finer work, they can be used upright and, if necessary, sharpened to a chisel-tipped end with a sanding pad.

This drawing constructs the figure in layers. Rounded arcs of line find the curved forms of shoulder, inner thigh, knee, back of hand, and head. Darker lines then accentuate the edges of the form. The rendition of the model has been built upon a framework. We're allowed to see into the structure, to get an understanding of the drawing's construction. Lines have been overdrawn, adjusted and repositioned.

Note that Conté crayons are rich in pigment, and therefore good for working with on darker paper. Manoeuvring them on the paper surface works best with a paper stump and a kneadable putty eraser rather than with fingertips.

FIGURE STUDY #1
Medium: Conté crayon

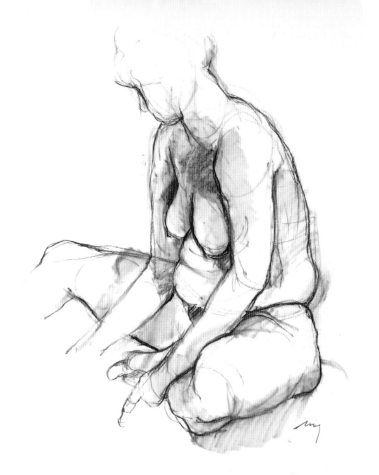

Neutral environment

PHILLIP DVORAK

This female model could equally have been drawn in an informal public space – such as on the beach – as in the formal space of a life drawing room. Her pose is such that she could be winsomely looking at something in the far distance, or have been asked to hold a nuanced pose, with weight gently skewed to the left. Such is the subtlety of body language and how we might read it. With no background information or suggested environment to give us clues, we can make our own minds up.

The drawing has been executed in charcoal. Linear mark-making traces the contour of the model's outline against the blank space she looks towards. The thick and thin of the line quality reveals a shifting of the charcoal in the artist's hand as he held it against the paper, looked at the model's position, then considered the direction of the continuing line. This is not a drawing that uses a faint preliminary guideline to lead the way.

The way in which shadows fall on the model's form suggests that she might be toplit from at least two sources. In a life drawing room, it is usual to have lamps that allow this kind of interesting tonal play. Outside, this might happen as the reflection of the sun bounces off nearby objects and onto the subject. Observing the fall of light and shadow, Dvorak has used dabs and curved, layered smears of charcoal to describe form. The space under the model's left arm is the deepest, blackest shadow – on a par with the blackness of her hair. Elsewhere, a range of mid-tones/values reveals the dip in the small of her back, the vertebrae of her spine, the shine on her hair and, quirkily, a bikini line.

UNTITLED (FEMALE NUDE)
Medium: Charcoal

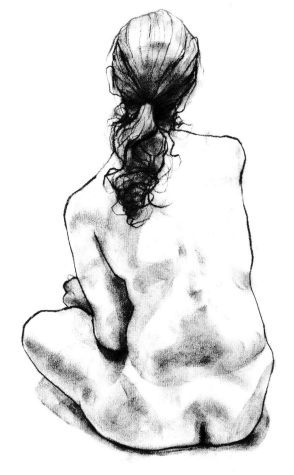

Generative drawing

PAOLO ČERIĆ

This image is Čerić's interpretation of a statue by Bernini. It's been worked up from a photograph of the sculpture. The artist has selected the viewpoint that most interests him. This is only one small portion of a complex Baroque marble that depicts the taking of Proserpina by Hades into the underworld.

The surface of this image ripples and shifts when we look at it. We might ordinarily attribute that to use of a textured paper. The optical effect is actually due to the way in which Čerić has initiated this drawing. This seemingly hand-drawn image is, in fact, a computer rendering. Čerić is a purely digital artist who is interested in interpreting found images with a single spiralling line.

The spiral starts in the middle of the page, at the waist of Proserpina. It winds outwards with a black line that shifts in width and saturation, emulating tonal changes.

The image gradually builds up, the one line mimicking light and shadow, resulting in a 3D effect.

Generative or algorithmic art has been an important part of the visual arts since at least the 1970s and 1980s, when computers became more accessible to artists. An algorithm is simply a detailed recipe for carrying out a task. One could argue that this isn't really a drawing like the others in the book as it's not drawn by the human hand. I would tend to disagree. It has an aesthetic quality that belies its mechanical production. If an artist working by hand followed the same drawing 'recipe', the outcome could be similar.

PROSERPINA
Medium: Digital

Working things out

MICHAEL REEDY

Life drawing classes are often taught through a balance of demonstration and supervision. It is really useful and inspiring to see a tutor talk and draw, especially in front of a professional model, in real time. This drawing was made during one such class. Graphite was used throughout the piece.

This pose is quite an awkward one to capture. The model leans forward, with most of her weight on her knees, but distributed through her right shoulder, and with her head turned away. Her right arm is underneath. This has caused her back to twist. It's that twist that makes this a complex drawing.

Look at the top right of the study. The artist has sketched out a simplified framework that echoes the model's pose. It uses straight lines. He's planning how best to draw this. The spine becomes a diagonal with hori-zontal lines crossing it. Their angle and spacing modulate to capture a sense of the ribs and that

important twist. Once worked through, the practice visualisation can be used to draw the framework of the model proper.

Once the framework of the torso was in place it was much simpler to capture other parts of the pose – for instance the angle and position of the leg. Holding a pencil at arm's length with one eye closed, one can measure the distance between objects and make comparisons between them. This method is called sighting. It's an important device in a life drawing room, as it quickly and constantly allows you to check on proportion. Only when he was sure of his measurements did Reedy strengthen lines and add details. Note that he held his graphite medium lightly throughout the exercise, building up his observations layer by layer. This working drawing reveals his processes perfectly.

UNTITLED
Medium: Graphite

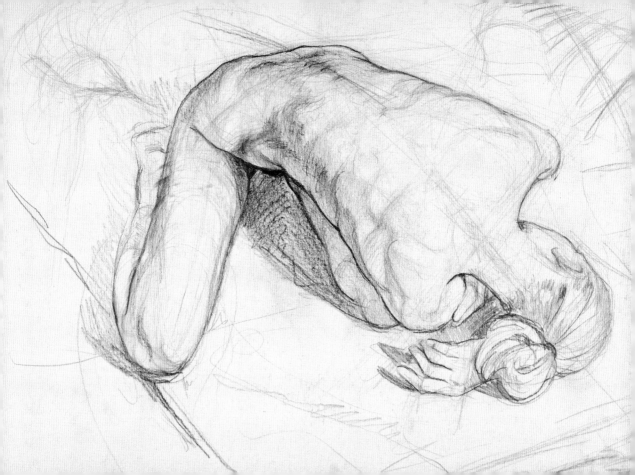

Dashes and squiggles

YADGAR ALI

The reclining nude has been a classic pose in fine art for many centuries. The model is usually seen straight on, the body spanning the width of the composition. Their hands and feet tend to remain inside the frame. Historically, those depicted are predominantly female, and they often face the viewer.

This charcoal drawing explores the idea of this classic pose, but transposes it in a contemporary way. It is drawn with no continuous discernible outline as such. The many marks it is comprised of flirt with the paper surface. They seem agitated and staccato-like – a dash here, a twist of line there. They dance around the space. Consider each of these party streamer-like lines separately. They are like a dissembled, unknown foreign script. It seems unlikely that multiples of them would come together to depict a figure, but they do.

A relatively large 59 × 84-cm (23 × 33-in) drawing like this is best executed standing up at an easel. The charcoal residue that cascades down the surface of the paper provides the clue that this is how it was completed. To make marks like this, and to see what you're drawing, it helps to frequently move back from the paper and to squint at the work; this can bring the image together, make it seem clearer. A sitting position would produce a different outcome. The mark-making would have less of a flourish to it.

DRAWING STUDY (10)
Medium: Charcoal

A pre-prepared surface

JYLIAN GUSTLIN

Speedily rendered, multiple 'warm-up' drawings are common practice in the life room. They help us to relax, to put more emphasis on really looking, and less emphasis on merely making a 'picture'. Attempting to draw the model rendered in several positions on the same sheet of paper like this is quite unusual. This is because it can be difficult to divorce one's looking from what's already on the paper. It can make things confusing. However, if one is able to work out a method to make things easier, the reward is a dynamic and interesting drawing.

Consider preparing your paper before beginning to draw. Marks on a surface can quite often help to anchor our looking. (See page 144 for more on prepared paper.) This paper is not pure white, or flat. Its starkness has been softened with smudged charcoal and olive-green painted stains. The surface has creases in it and some pasted-in/collaged paper, too. The collage strip acts as a platform on which to place the model's feet.

That layered section may have been the pivot of this drawing, and what made its multiple layers possible to achieve. Note that the three separate drawn figures settle at that one point. Only the ankle and foot of the figure on the right is featured at all, and yet the other two figures seem to share it. As the model has turned around we get views of her from the back, front and side. Viewed separately, the three drawings would seem incomplete. Combined like this, we see a dynamic, multi-view study.

DRAWING 5
Medium: Charcoal, pastel, pencil, paint

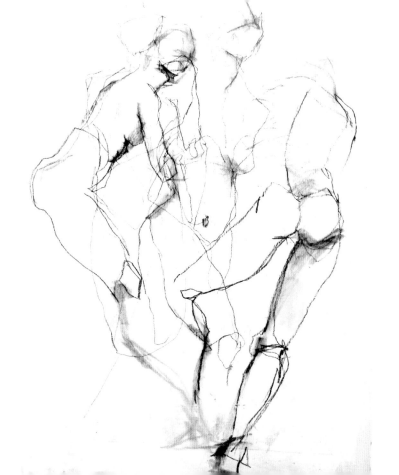

Traced contours

ALEXANDRIA ANGELO

There are several examples of continuous line drawings in this book (see pages 52, 102 and 186). The characteristics of this one are slightly different, however. The lines here are cleaner, more flowing and sinuous; their weight and width is the same throughout, plus the line maps the edges of areas of tone, as well as the form's outline. It's when using tracing as a method of drawing that these characteristics emerge.

Let's be clear about this approach – tracing is absolutely a viable way of capturing the figure on paper. I've often had conversations with students who think it's 'cheating'. Not so. Tracing may seem simple, but I've seen many lazy and bad drawings done this way. Done properly, tracing is just another, and very useful, drawing method.

This drawing is an example of a continuous line tracing that is both spare and elegant. The artist has chosen to draw from a studio-posed image. Her background in

fashion illustration means that she sees many photographer/stylist-designed magazine shots. She has selected exactly the characteristics of a pose that will suit her composition.

There are a number of ways of emulating this drawing approach. You could use specially designed translucent tracing paper layered over your image; a tracing app on your smartphone or tablet – import an image, adjust it and trace over it on the screen; a digital projector – great for scaled-up, traced wall drawings; or an illustration program on your computer.

LUCIA
Medium: Pen

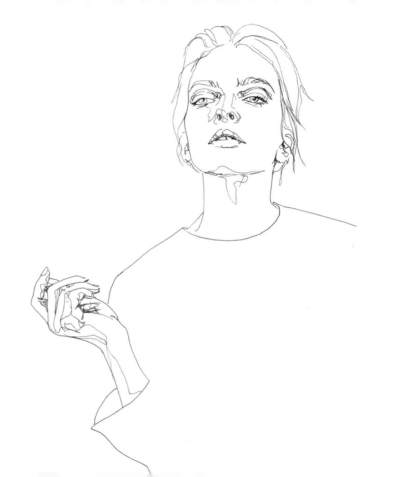

An expressive pose

PHILLIP DVORAK

There are works in this book that explore expressive mark-making. This drawing places as much emphasis on the pose itself being expressive, with the model placing his hands behind and over his bent head. This kind of unconventional, contorted body shape owes much to the work of the early 20th-century Austrian artist Egon Schiele. Seeking out, viewing and analysing the works of well-known figurative artists can often proffer new ways of approaching life drawing. I'd recommend visual research from a primary source whenever possible – seeing drawings, paintings and sculptures firsthand in museums and galleries whenever you can.

Dvorak's style of drawing is definitely his own. His method is to use compressed charcoal (blacker than willow/vine charcoal) to map out an outline of the model. He's interested in cropped compositions where that outline goes off the edge so that the figure is not contained within the boundaries of the paper. He's used his fingertips to drag passages of charcoal within the outline. Some of these marks are lines but on a much broader scale. They're used to draw the spine, and also to block in areas of tone – on the fingers, under the arm, and for the deeply black hair. Dvorak has an individual style of adding fingertip swirls to his work, too – a patterning that extends beyond the model's pose and into the negative white space around it. (Compare with Marilyn Kalish's expressive marks on page 131 and Mirco Marcacci's surface patterning on page 189.)

Twisted poses, with arms held aloft, are not easy for a model to hold for long periods of time. Dvorak only took twenty minutes to complete this drawing. He is lucky enough to have the confidence, experience and considerable drafting skills to do so.

UNTITLED (MALE NUDE) 6
Medium: Charcoal

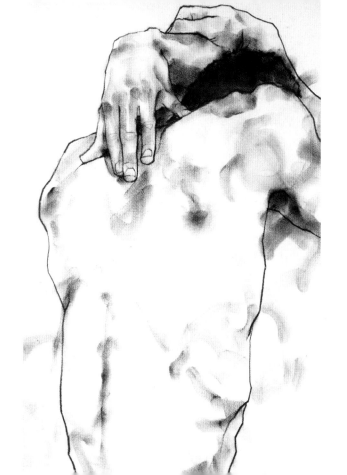

47

Close up

The orientation of your sketchbook influences how you draw, and in compositional terms, what you draw. Heaston has selected a small sketchbook that is bound on a short edge. Its spiral binding means that he can quickly flip the page over and move on to the next page, knowing that the paper will remain flat. A diminutive sketchbook is easier to hold – supported in one hand, drawing with the other – standing up if necessary. This is ideal for capturing precious moments like this.

These sketchbooks are often used when travelling. It's easy to see why; they slip into a pocket or bag easily and are relatively inconspicuous when used in public. In a busy domestic setting they're just as handy. The birth of the artist's child must have been a busy time. He hasn't let the new schedule stop him from drawing.

The sequence is an interesting one. The first drawing suggests Heaston didn't know how long he had to make the drawing before his baby woke up. He was being

opportunistic by taking up his fineliner pen and sketchbook. Baby and bouncer are included, details are minimal and there's lots of white space. On the second attempt, he has moved closer, realising how a variation on the first drawing might improve things. This drawing is more of a portrait. The bouncer doesn't dominate the space so much. More detail is included. Contour line and some hatching depict clothing patterns, soft toy and pacifier.

JUNI NAPPING 1 & 2
Medium: Fineliner pen

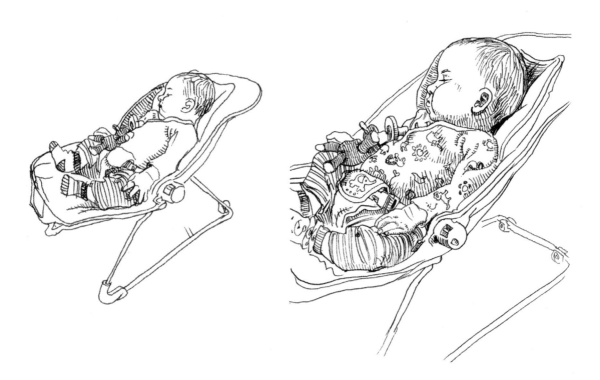

Comparative study

PAUL RICHARDS

The timing of poses is usually determined at the outset of a life drawing session. It's a useful factor in helping you decide what you might do in the time available. A habit of this artist is to draw the same pose repeatedly in an attempt to simplify or find something he may have missed. He's used the same materials for each drawing – a graphite block and A2, 90-gsm cartridge paper. Retaining constants like this can be a good idea if you're intending to use your output as a critique of your best practice.

Richards mixes and matches methods in his quest to challenge his drawing habits. Sometimes he draws with his other hand, alternating between left and right on each pose. He has also been known to draw with both hands on one image. These are all attempts at trying not to become too methodical.

'As your skill develops, you may be inclined to repeat your own success, knowing that a pleasing result can be obtained by doing what you've done before,' he says. 'Whilst my current output using speed and gesture may itself be dogmatic, I find the "accidents" more frequent and pleasing. Occasionally, when things go well, I am able to get into a "zone", where it feels that I'm less conscious of the decisions of where marks are made on the paper. At some point, this will change and another approach will be needed – that's the exciting part.'

UNTITLED 2 & 1
Medium: Graphite block

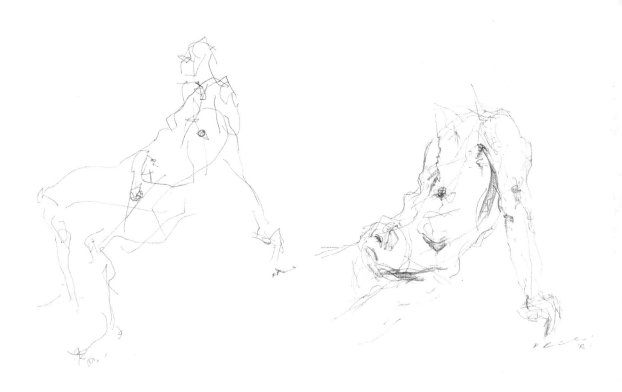

51

Multiple portrait

JYLIAN GUSTLIN

What's interesting about this drawing is that it's actually a combined portrait of several of the artist's nephews when they were younger. Each layer is a different individual, but we read them together as one.

To be able to draw confidently like this – especially when portraying those we know – takes practice. This seemingly flowing and spontaneous drawing is successful because of decisions made before starting: the composition, how much of the paper is taken up by preliminary charcoal oval, and knowing some simple rules about the proportions of the face.

A drawing like this is made by utilising continuous line. The artist's drawing implement is in contact with the paper at all times – not just when looking at the paper, but when viewing the subject, too. The energetic flowing line is entirely suited to the subject; the lines are exuberant and constantly on the move.

Observation is key. The observer's eyes should probably stay longer, time-wise, on the person being drawn than on the drawing itself – not for long stretches of time, but in a constant looking back and forth between sitter and paper. The artist has applied that rule several times as she swapped between media, each searching layer finding the right form. Look at how earlier charcoal marks can still be seen, but have been smudged away so as not to be dominant in the final, darker, more certain, blacker lines. Only when these were in place were the red lips and the family's shared characteristic – their brown eyes – added.

DRAWING 6
Medium: Charcoal, pastel, pencil

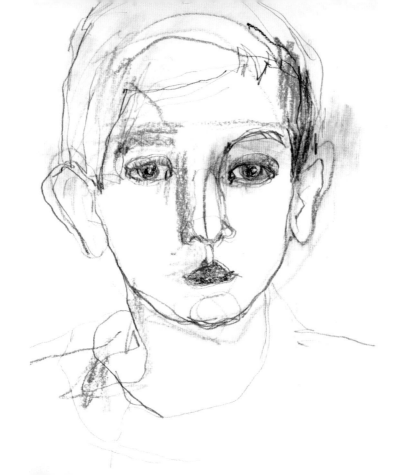

Line and mass

DEREK OVERFIELD

Consider using yourself as a model. A self-portrait done using a mirror placed at an angle makes for an interesting composition. It's a device commonly used in fine art practice (for example, by the painters Lucian Freud or Jenny Saville).

This powerful drawing combines two techniques: blind contour drawing, and mass gesture drawing. Both work best with eyes kept mostly on the model, and minimally on the paper, while the medium – here chalk pastel – stays in contact with the paper most of the time.

The single, sinuous line of this self-portrait typically characterises blind contour drawing. Imagining that the end of the medium used is in actual contact with the subject creates the technique. If you try it, don't let your eyes move more quickly than you can draw. Begin at the outside edge of your subject, but when you see that line turn inward, follow it. Don't retrace lines and don't erase anything.

Mass gesture technique is so called because the drawing medium is used to make broad marks, which create mass rather than line. Instead of line created by the chalk pastel's tip as previously, its whole length is used for drawing with the chalk held parallel to the paper. The gestures made with the chalk pastel aren't copying what the subject looks like; they're describing relationships between form. Look especially at the darkest tones at the side of the torso and the cheekbone. This work is about weight and substance. Note that when you are using chalk pastel or charcoal, this technique works best on larger paper at an easel. This work is 45 × 60 cm (18 × 24 in).

DRAWING 145
Medium: Chalk pastel

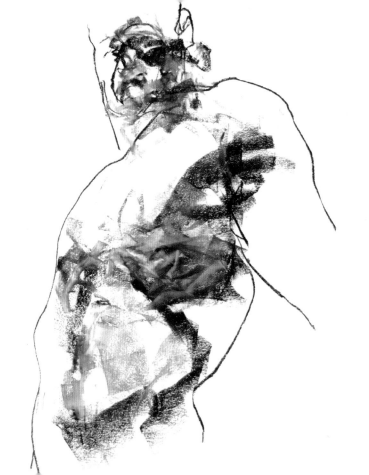

A drawing project

MARIA GIL ULLDEMOLINS

We think of a head-and-shoulders portrayal of a person as a portrait – face towards us in some way. A different approach, one where the sitter's hair becomes the focus of study, is an interesting alternative.

A combination of personal memory and recent discovery prompted this artist to embark upon this sequence of hair studies – firstly the (re)discovery of a childhood drawing book, Ernst Röttger's *Creative Drawing*, and more recently finding a Flickr group called 'Braid Wednesday'. This project was sustained over two years. There are stylistic differences in the pen work. It's inevitable that one's drawing style might change during that time.

These drawings have obvious traits in common – portraits in reverse drawn with a black marker pen on white paper. All are posed in such a way that we get the best view of the models' hair. The artist pays close scrutiny to what hair actually does – how it falls,

its shape, what it does when it's gathered, manoeuvred and held in place. She's worked on one part of the hair at a time, following the direction of the strands, finding a flow and pattern to how things fit together. She hasn't tried to draw every single hair (a mistake that is often made). Instead, her line work is sparing and methodical. It lends the drawings a graphic quality.

Develop a habit of taking note of possible drawing starting points that present themselves to you, whether in the margins of your sketchbook or in the notes app of your smartphone. Choosing a drawing project that inspires, pleases and motivates you, for whatever reason – especially when the output can eventually be viewed like this – is very satisfying.

BIANCA, BRIDGETT, KATHERINA, STELLA,
BUNS AND COMBS, GEISHA'S THOUGHTS,
REBECCA, LIZA
Medium: Fineliner pen, Indian ink

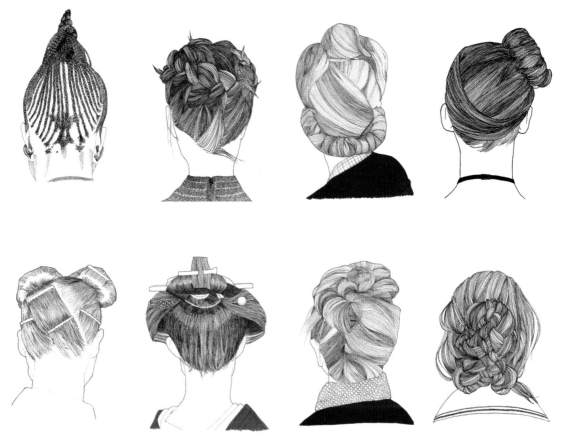

Travel kit

BRYCE WYMER

One of the best places to do some figure drawing is while travelling on public transport. It means you're surrounded by others and have a ready stream of models to sketch. Knowing how long a journey is likely to be is an important factor. On a plane journey like this, you can gauge how much drawing time there will be. A model distracted by onscreen entertainment means you can quietly get on with your observed drawing unobserved.

Carrying a minimal but good-quality drawing kit makes this kind of figure work much easier, and pleasurable to do. A good-quality sketchbook, like the Moleskine used here, is invaluable. It has acid-free, distinctive creamy paper, and a hard cover with elastic closure. This means drawing work travels flat and undamaged. Sketchbooks with soft or loose covers bend and move. Drawings in them become smudged and creased.

A propelling/mechanical pencil ensures you'll always have a sharp point to draw with – no pencil sharpener or craft knife required, just a click on the end to reveal more lead/graphite. Most propelling/mechanical pencils come with an eraser, too.

This is an artist who doesn't make sketches with a throwaway, temporary attitude. In addition to the above, he uses good-quality pens. The Sakura Pigma red Micron drawing pen used here is a disposable pen that uses archival pigment ink, which is much favoured by illustrators and artists because, like the Moleskine, it's acid-free. This means work remains stable and is fade resistant.

HURRICANE SANDY
Medium: Propelling pencil, red Micron pen, gouache

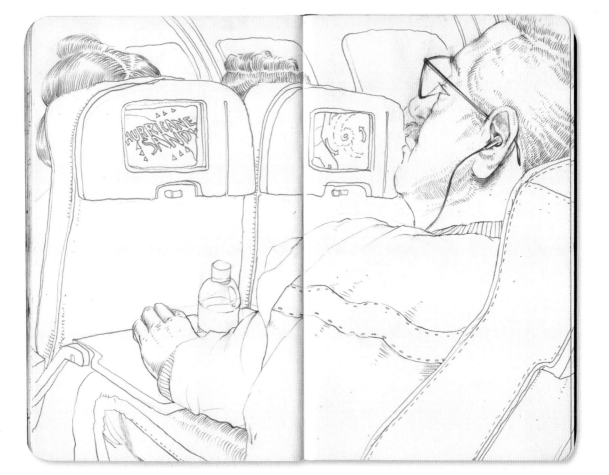

Limited colour palette

JULIAN LANDINI

This predominantly red-and-black drawing has been executed with rollerball pens. They contain a liquid, or gel, ink, normally dispensed by a smooth ball. They are different from ballpoint pens in that they don't allow tonal variation with change of pressure. As soon as their tip touches the paper, the ink flows. Pressing harder can, however, give a slightly broader line. If you need more variations in line width, these pens are usually available in several sizes.

Landini's drawing makes good use of the medium. It's bold in execution, having the characteristics of a print with its pared-down colour palette, use of white space and interesting compositional properties. An action shot like this would necessarily have to be worked up from a photograph, and it is this source that has provided the 'cut-off' edge and interesting composition. A camera is a great device for framing the figure. It provides new viewpoints and opportunities.

Lightly rendered pencil guidelines have provided the layout of the drawing. Pen lines can't be erased, so some visual clues are important. The balance of black and red is just right, as is the choice of line to describe different surfaces and edges. The fabrics have been filled with a robust back-and-forth mark – lines lying parallel to one another. However, the hair of the person and the fur of the cat are more flowing and organic (the cat's fur rendered using a finer pen). The lines used to separate white from white – face and clambering cat from background – are ingeniously rendered, utilising each of the main colours. Extra touches – the turquoise of the cat's eyes and the pink of the girl's cheek – complete the drawing.

RETRATO INTERRUMPIDO POR UN GATO
Medium: Coloured pens

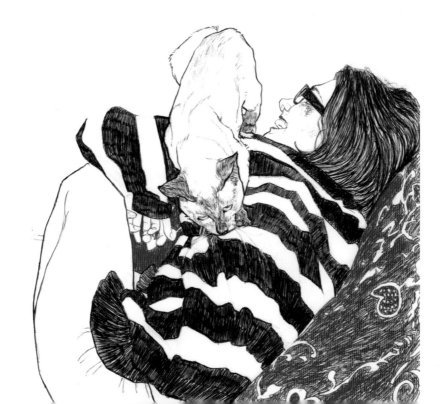

Speed drawings

KATIE LOUISE TOMLINSON

A sketchbook, soft pencil and broad-tipped felt-tip pen was all the drawing kit Tomlinson needed to achieve these reportage-type drawings while on the beach in Italy. (See page 154 for more on reportage.) There's much to be gained by not over-complicating what's required for the making of good figure drawings. The relaxed ambience of the scene, and the artist's own part in it, is reflected in her fuss-free approach.

Using a hardback sketchbook like this one means the drawing surface is a stable one. It's possible to draw standing up – although I'm fairly sure that like those around her, the artist sketched in a much more casual position. A softer graphite pencil has allowed her to create a variety of line qualities – thin and thick and grey through black – simply by varying the weight with which she handled it. There's a real urgency to some of the lines. Tomlinson wanted to capture the basic characteristics of individual postures or movements before the moment was lost. Speed was of the essence.

The artist hasn't concerned herself with tone in this collection of drawings. We can assume that the scene was brightly lit by the overhead sun, so any subtle shadows have been minimised. What she has done instead is use a red felt-tip pen to pick out details like bikini patterns, swimming shorts and deckchairs. She only used it to draw one figure. Let's hope that's not because he was sunburnt!

Compare these drawings with those by Deanna Staffo on page 31. Tomlinson hasn't tried to describe the environment of the figures. However, the cream paper and multiple drawings allude to a crowded beach, and so are similarly successful.

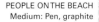

PEOPLE ON THE BEACH
Medium: Pen, graphite

Found paper

Sitting in a public space, we are often faced with advertising hoardings, posters and screens. Images can flicker around us constantly. If there's something that catches your eye, don't hesitate in trying to draw the essence of what you see. Don't make excuses like, 'But I haven't got my drawing materials with me.' Using the most humble of materials one has to hand can sometimes be the only way a drawing exists at all. Here, the front of an envelope and a blue ballpoint pen served the purpose. A doodle of an idea has been built upon, and then filled out because of visual stimuli.

It's quite a curious thing to choose to draw a face at this angle – almost upside down – simply because this is not usually how we relate to one another. A preliminary, lightly marked cross provides a guide. It's useful to do this when drawing a head face-on, especially at an angle like this; it helps with positioning the features.

If you're interested in drawing the figure, you often find parallels between what you might have been working on in the more formal setting of the life drawing room, and the things that catch your attention in the outside world. A quick sketch on a scrap of paper while out and about can often help solve visual problems when we're back in a more formal setting again.

Like many artists, van der Meer finds inspiration in a lot of images he finds around him in the public arena. Interpretation and combination of multiple references can help to make a totally different and new image, as here. Consider it for your approach, too.

TIRZA
Medium: Ballpoint pen

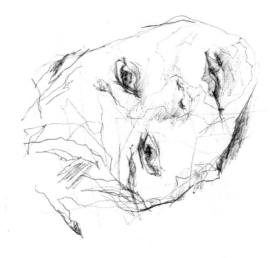

Triptych

DWAYNE BELL

Bell's postcard drawings are produced as part of the work he makes each day on a regular bus journey. His job as an illustration lecturer necessitates a daily round trip of two hours, time he's determined to use creatively. He's learnt to adapt to the movement of the bus and the confined space offered by the seats.

Placing three images together like this – a triptych – is a visual device that has been used since at least medieval times, especially in Christian churches. Contemporary art works utilise the idea, too (figure paintings by Francis Bacon being a fine example). The border that Bell leaves between his drawings is a device often used when arranging photographs as a triptych sequence. A three-part drawing like this could be planned with a smartphone camera. Most phone cameras now come with a 'pano' setting; with this on, one can effectively change the parameters of a photograph, stretching its format lengthways to suit. The split into three can be done on the phone, too.

Look at the middle panel in this drawing. Isolate it from those on either side. By itself the back of the person's head in the foreground doesn't make much sense, becoming an abstract shape. A camera can resolve this and show that it can work – trust the idea, so that you can confidently begin drawing, using your phone screen as a compositional aid if necessary.

By using a panoramic view – joining three of his postcard drawings together – Bell elongates things, allowing us to see the wider environment of his commuting space. We get a greater sense of his sitting position, his view along the length of the bus – a sense of place.

CROSSHATCH PANO
Medium: Fountain pen

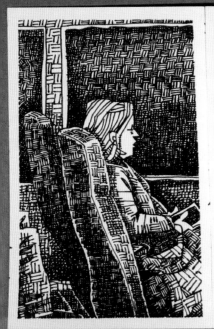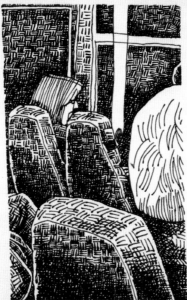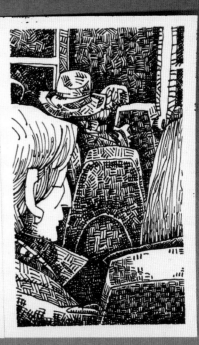

Black pencil

MARTIN ETIENNE

Being opportunistic is often the best way to capture a pose as natural as this. There are several sketchbook renditions of people travelling in this book. It's evident that many artists use their journeys to best advantage – getting from A to B and gaining a souvenir of their trip, too. These kinds of drawings are of value. They engage us in looking, finding, selecting and thinking – all inherently good visual practices to maintain. They can be journalistic, too, recording moments.

This is a pencil drawing. (Compare it with the propelling pencil used in Steve Wilkin's train journey drawings on page 87.) The depth of the black is very noticeable. This density is not achievable with a graphite pencil, even one with an especially soft lead; these will still make a greyer mark at their darkest. However, a carbon- or oil-based pigment pencil makes rich, velvety marks. Here, this kind of pencil is particularly successful in capturing the unique surface quality of the woman's leather jacket.

Diverse line quality can be achieved, depending on how you handle these pencils. With a sharpened lead, a drawing can be fine and more accurate, whereas with a half-worn lead, the paper can be more vigorously filled. Compare the lines that map out the image (most visible on the seats), then the woman's face, and lastly her clothing. One can see, as the drawing progressed, that the point gradually wore down. This was not disadvantageous – a range of successfully descriptive line and tone is the result. These pencils are best sharpened with a knife then shaped with sandpaper.

Some recommended black pencils: Wolff's carbon pencils; Conté à Paris Pierre Noire sketching pencil; LYRA Rembrandt Carbon Pencil; Cretacolor Nero.

A NAP ON THE TRAIN
Medium: Pencil

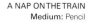

Repetition

BRIDGET FARMER

Four drawings of the same form in a row allow us to see how each observational drawing in a sequence alters slightly, but is no less relevant in capturing what was seen. What we get is something that is reminiscent of the childhood game of 'spot the difference'. Looking at the artwork, it is difficult not to scan back and forth along the row locating curves, different decisions and, perhaps, deciding on our preferred rendition.

This picture has been drawn with pencil. The artist's aim was to sketch quickly and to do so using repetition. There was no need for her to use speed and spontaneity to capture the model, as she did not draw from a live one. The subject matter here was a manikin.

Manikins and mannequins are commonly used by artists and designers. It's worth knowing the difference. A manikin is a life-sized anatomically correct human model. It may be used educationally – artistically, as here, or medically. A mannequin (sometimes called a dummy) is less likely to be 'true'. An elongated, slimmed-down fashion mannequin, for instance, is designed to make clothes look good; it's not necessarily meant to be true to life!

The obvious point to make here is that the manikin isn't going to move. You can take as long as you like to make your drawing. This artist could have spent longer on this pencil drawing because of this; she could have corrected it, perhaps neatened up her lines. However, perfection wasn't the point of this drawing's approach. It was to create flow, to practise, to search for and find the manikin's form.

FOUR LADIES
Medium: Pencil

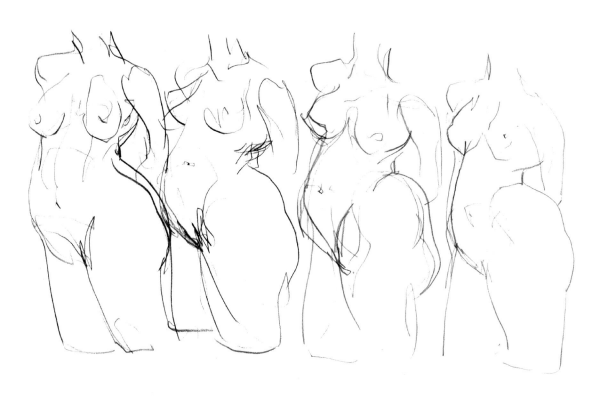

Know your subject

KATIE LOUISE TOMLINSON

Tomlinson produced this drawing as part of a series. The emphasis of the sequence was to draw from life – not simply to take photographs and work drawings up from them. The aim of the drawings was to record the creative process – from start to finish – of the final year of a graduate fashion student. Here we see the student at work on an industrial sewing machine, where he is beginning to experiment with and construct one of his garment designs.

Working directly from life like this lends a drawing more urgency and vibrancy. Drawing decisions are influenced by the situation one finds oneself in, and often make a drawing seem more dynamic and less static. Tomlinson will have gauged what was still and constant in this scenario and what wasn't, making her drawing choices based on that observation.

This image is reminiscent of a print, because of its handling and its limited colour palette. Tomlinson has drawn with ink in several forms – fineliner, ProMarker and applied with a roller. The fineliner has been used to quickly map out the spools of the thread in the foreground, the sewing machine and the stance of the student in the middle ground, and finally the mannequins in the background. The lines are swiftly rendered and unfussy. They set out the scene. ProMarkers have provided heavier line weight for the criss-cross of thread, texture of jumper and tousled hair, plus the blocking-in of yellow. A paint roller has provided a chunky slab of black drama and texture to the right of the drawing.

SEWING MACHINE
Medium: Fineliner, ProMarker, roller

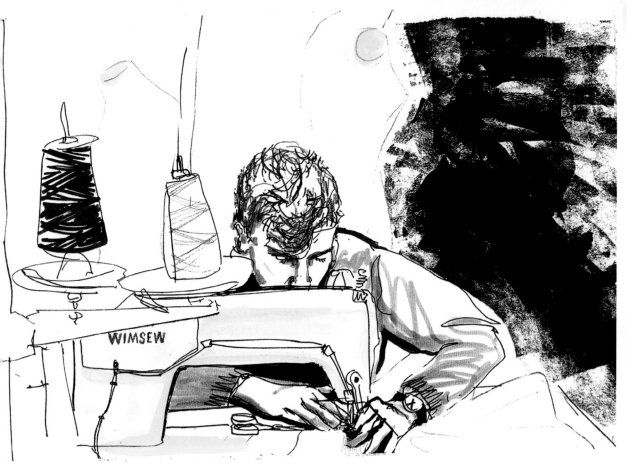

Knowing your model

Isabella is a designer. Her work in the applied arts ranges from book illustration to packaging design to textile design. Like many artists who draw, make and visualise every day for a living, downtime can also be a time to do more of the same. The difference is that this drawing wasn't made to be 'applied' – it is a drawing study (of the artist's husband) for its own sake.

This sketch is very much about capturing an ordinary moment using ordinary materials as the moment arose. Graphite pencil has been used loosely and very lightly to begin with, while red and black watercolour pencils defined things further without any overworking. Everything feels very natural and flowing.

The paper used is newsprint. This cheap paper is often utilised in life drawing classes for quick-fire drawing exercises, so that any preciousness that might affect exploratory, experimental drawing outcomes is avoided. As the name suggests, this paper is used in the newspaper industry. (Note that newsprint is not printed with anything when you ask for it at your art supply shop. It is blank paper.) Be aware that it is non-archival paper. Its high acid content means that it yellows and goes brittle with exposure to light (as newspapers do). Do not use it for exhibition purposes, as it will deteriorate while on show. Photograph or scan your work, or, as here, have it featured in a book!

It's useful to have a person who can serve as your inspiration in informal settings such as this. You are more likely to know how long the 'pose' will last for, and through repeated observations of the same person will probably develop a much more knowing, flowing line. The artist herself says that familiarity with her husband makes him an easy subject to draw. There is nothing formal or posed about this everyday situation.

RESEARCH IN THE COTTAGE
Medium: Graphite pencil, watercolour pencil

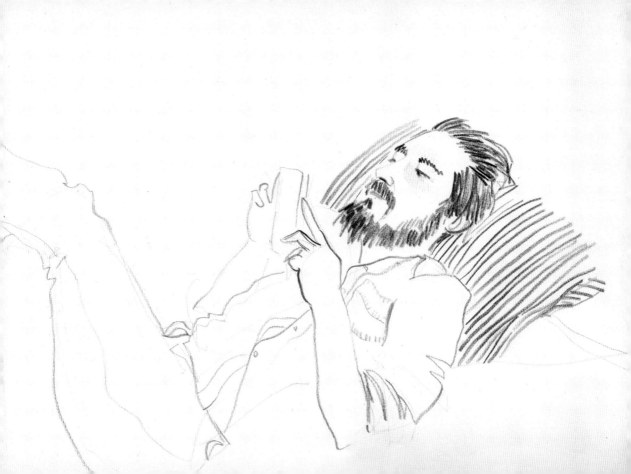

Shifting your stance

JONATHAN KRÖLL

Drawing from a nude can sometimes be about producing unassuming, modest work. This work by Kröll is noticeable because of its simplicity. The most basic equipment is used – a pencil and a sheet of A4 paper. The line work is doodle-like and the space inhabited by the drawing is very plain. An empty space like this makes us focus our attention. The composition is well selected because it makes us think more about what is happening?

A deceptively simple drawing like this can be more complex than it at first appears to be. Consider the pose. The model is curved around in a foetal position, arms folded, legs drawn up to the body. Is this someone sleeping comfortably, or is it a psychologically regressive position? The anonymous form has been drawn in two separate parts. The bent legs were sketched while observing the model from the front; the upper body was drawn from behind. One portion has been placed above the other, giving a feeling of unease or disjointedness.

This drawing demonstrates that drawing a nude does not have to be a sustained affair. Compare the drawing method applied here with a quick sketchbook piece one might do while out and about. The essence of that approach is: draw now, before the moment is gone. If working at a small scale in a life room, i.e. not at an easel, one can move around the model more easily. There's no need for the pose to change. You change your position instead. If you decide that a life drawing session will be utilised to make many drawings rather than one sustained drawing, you too might build up a sequence of small but powerful sketches like this.

Try drawing with your 'wrong' hand. It produces some interesting line qualities. It can feel awkward, but is liberating!

SKIZZE/SKETCH 2013-04-24
Medium: Fineliner pen, Indian ink

Using vintage papers

A patchwork of reclaimed, vintage papers forms the surface for this drawing. The sheets have been arranged in a quadrant, but not over-precisely. The paper hasn't been trimmed. Its deckled, torn, eroded and worn edges are an important part of the piece. The paper surface reveals folds, creases, holes and cutouts. The aged, mottled, light-damaged and yellowing paper lends warmth to the image.

The young female model looks away from us. Distance is suggested by an oblong patch, top left – a light bleached area. Three square holes above it could be seen as small windows allowing in the light. A numeral, 3, sits behind one of these apertures. Bottom right we see a sequence of numbers upside down and back to front. Such obvious use of pre-used, scrap-like paper is unusual in a drawing that is most certainly not throwaway.

The young female model's neck, shoulders and ears are rendered simply. Faced away from us, she is anonymous. She is made known to us through her

hair styling only. That hair is rendered in black pencil and with a dipping pen and ink. It is carefully observed. Look at how the parting isn't actually drawn; it's merely an absence or meeting place of lines. Strands of escaped hair feel real. The black ink adds an extra depth of tone. The hair seems glossy because of it. (See also the hair observations of Maria Gil Ulldemolins on page 57 and the black pencil work of Martin Etienne on page 69.)

If you decide to use old papers like this, take into account that they won't exhibit or store well. Exposed to sunlight, they will discolour and break down further. Scan or photograph your work in high resolution while it's looking as you wish.

SAILING SHIPS
Medium: Pencil, pen, ink

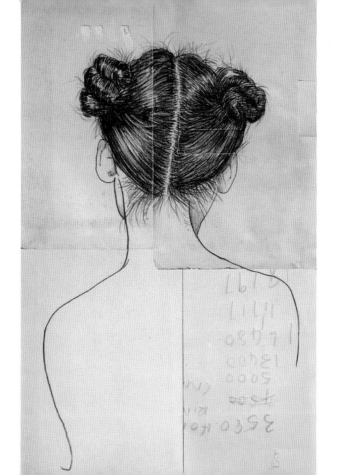

A temporary model

YADGAR ALI

In my experience, art students eagerly await life-drawing lessons. Once the ritual of finding a good place to set up an easel is accomplished, its height and angle adjusted, paper taped to drawing board, and various media are lined up, the appearance of the model is a significant moment.

On occasion I've experienced a class where the model hasn't been able to attend. The disappointment has been palpable. However, there's never a need to cancel if some class participants are willing to take on the role for a while (clothed!). Sustaining a pose is a good thing to try temporarily – it teaches you not to underestimate how difficult the role of a life-drawing model is. It gives you an understanding of how to utilise and negotiate with models, too.

Here's an example of a member of a student group being the model. She's been given a pose that is slightly easier to sustain because of the props used. Seated on a stool, leaning forwards, hands grasping the sides of a small table – all this ensures there is no 'wobble' factor. This is a secure stance.

The contrast between geometric, inorganic form and the model's organic shape makes for an interesting, rapid drawing. Ali has used pencil to quickly draft in the table – it's important because of the forward-leaning weight of the model. He's spent more time on what's important, though – the figure. When using a member of your peer group I wouldn't suggest a pose any longer than 15 minutes. Ali knew the time limit and so prioritised what was important.

DRAWING STUDY (4)
Medium: Pencil

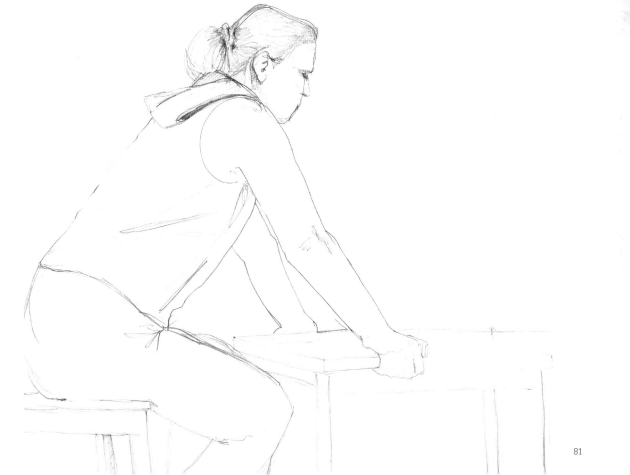

81

Anchor points

BRYCE WYMER

Choosing an informal space to draw the figure is as valid as working in a formal life-drawing room. The difference with this 'real life' scenario is that your model is more likely to be moving! Wymer has used his sketchbook and taken advantage of that fact; his drawing observations include the changing positions of the bather as a series of overlaps. This layering has resulted in a drawing that is more animated, with movement mapped.

Look at how the head has two positions – one more upright, the other with the head resting on the bath's edge. How many pairs of arms are there? Perhaps five or six. There's a real sense that this is someone doing ordinary day-to-day stuff; sliding down in the water, sitting up again, arms in the air. The trick to drawing like this is to use the surrounding objects as an 'anchor'. The objects aren't going to move; they're fixed, static. Once you've drawn them in you know the figure can be placed in, and measured against, them.

All of the preparatory line work was done with fine-ended (Micron .005) pens with permanent ink. There is no erasing. The white of gouache paints adds brightness to the cream Moleskine sketchbook page, becoming a kind of 'whitewash' or semi cover-up where corrections or enhancements to the drawing are wanted. Coloured inks – red and blue – help define the stages of movement. Previous doodles, patterns and annotations are still evident through these layers. They enhance the final work. Note that drawing with permanent ink means that washes or wet media can be added later without affecting the earlier pen work.

BATH HOUSE
Medium: Pen, watercolour, gouache

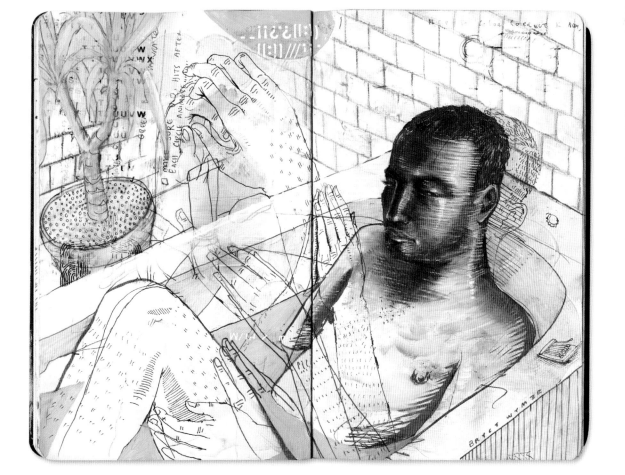

Black stone

Rambert has set up a pose that enables her to focus her attention primarily on hands and feet. She uses the most sparing of lines to map out this part-figure on 50 × 65-cm (20 × 26-in) cream paper. Drawing in this way is very difficult to do. There is no preamble, no preparatory guideline to lead the way.

With drawing as finely tuned as this, her medium of choice is important. She's used a Conté black stone or Pierre Noire pencil. It is soft and provides an indelible velvety mark. Its strong black line suits her requirements. Black stone is a mixture of carbon and clay. This is drawn with a 'B'-grade version – not too hard, so it's sensitive to nuances of drawing weight or the pressure of the black stone paper, but not too soft, so the lines are clean. (See also the black pencil work of Martin Etienne on page 69.)

That sensitivity to line use is apparent in this drawing. It reveals where Rambert has paused to think, to make decisions about line flow. It has a pulsating quality – from thin to fat, subtle to a more determined mark. Blacker marks can be seen at the shoulder, wrist and in numerous parts of the feet. These were probably her biggest challenge; they are very complex. Look at the model's left foot. The ankle and heel seem to have been drawn twice, as was the ball of the foot. These searching, correcting lines do not detract from the work at all.

This is an elegant drawing that makes good use of compositional space and sinuous line.

MÉLANCOLIE 10
Medium: Black stone

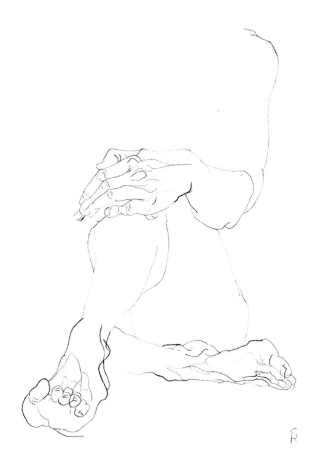

Journey diary

STEVE WILKIN

Due to the time constraints of his working day, which involves teaching others how to draw and design at degree and master's levels, Wilkin often has less time than he'd like to pursue his own illustration output. Knowing that it was important to keep observing and drawing, he figured out a way to do so – by using the hour he spent on the train getting to work each day. By nearly always carrying a sketchbook and propelling/mechanical pencil, he has captured the morning commute of others through the seasons. Here we see examples from autumn 2015 to autumn 2016 (we can tell the season by the commuters' warm clothes and hats). By the time this book is available, a whole academic year's worth of fellow travellers will have been captured.

Keeping to a regular task like this is a good habit to aim for. With a determination to keep to a drawing plan, you can find yourself maintaining a certain rhythm to your drawing you might not otherwise achieve. It means that you attain a familiarity with your materials and timings. Practice becomes perfect as confidence builds – as does your output.

On the strength of his collected train journey drawings, Wilkin was awarded funding to publish a newspaper. It featured selected images from his sketchbook, and in a neat circle of thanks to his subjects, was distributed to fellow passengers on his daily commute (see blog. newspaperclub.com/2012/03/12/738-a-journey-in-newsprint). His work has been featured in many blogs and books. Not bad for someone who didn't have time to draw, but was determined to find some!

COMMUTERS TEXTING, COMMUTER WITH SOFT DRINK,
WOMAN READING TABLET
Medium: Pencil

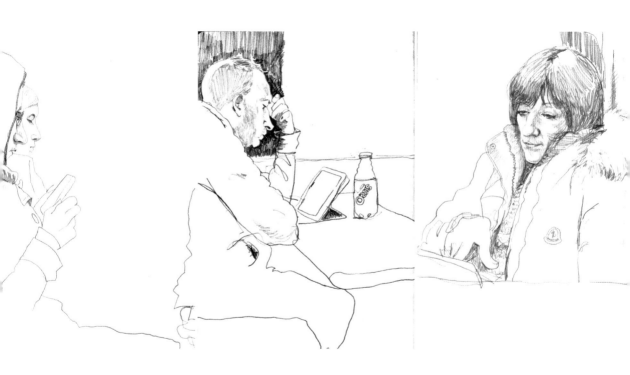

Avoiding distortion

It can be very difficult to draw the full length of a standing pose in proportion, especially on large paper, as here. Depending on the height of the paper, if it's on an easel, or the foreshortening of the paper, when drawing with it flat on a surface, all sorts of distortions can happen. Separating components of the figure can help to solve the problem. It's also a method for not being overwhelmed by the whole form. Breaking it down into parts in this manner can make things much more manageable.

It's often the legs, which tend to be the last part of a full-length drawing, that are most likely to go out of proportion. The artist has purposefully started with them first. He's placed them at the centre of the page and started at the waist, working downwards. There's a real sense that the weight of the model is on the left leg. Though this is a preliminary sketch, the figure is carefully observed and the line work is nuanced. Continuous line keeps everything flowing. Changes in pressure create accents of surety. The torso and folded

arms have been tackled next, and lastly the head and shoulders. The same swift, sure pencil work links the three studies.

There is a choice at this point; one can leave the drawing as is, or use one of these methods to re-unify the figure: cut out and reassemble, or perhaps trace them onto a fresh sheet of paper. (See also Jonathan Kröll's disassembled figure on page 77.)

Regarding distortion, there are standing easels and sitting easels. The latter is called a donkey or platform easel, or an art bench. One sits on it with the drawing board placed at an angle. Be aware that the top of the drawing is further from the eyes than the bottom, which can create distortion in the finished work.

DRAWING STUDY (14)
Medium: Pencil

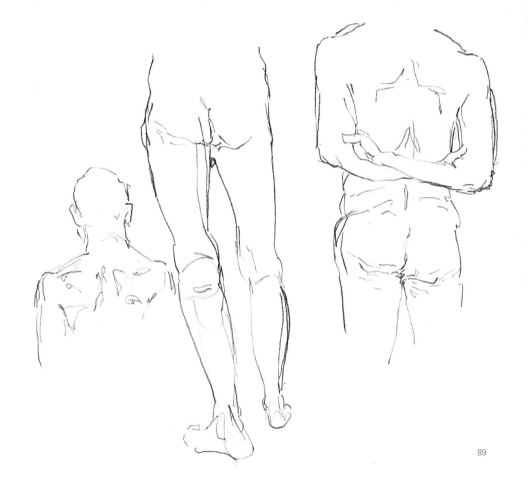

From the hip

AGATA MARSZALEK

This is a very natural take on a portrait and suits the young subject being portrayed. She's viewed from below, the framing and composition having all the attributes of a candid shot captured with a camera. 'Shooting from the hip' like this is easily achieved by holding your camera at waist level, taking the shot with it pointed upwards without looking through the viewfinder. The outcomes can provide viewpoints you might not otherwise consider.

Like a photo captured this way, Marszalek has included information from the subject's background – from above her and behind her. The detail of her environment fills the compositional space but is simplified to such an extent that it becomes a series of diamond patterns. Any over-detailing of this secondary information might have detracted from the portrait.

Decisions have been made about what the drawing pays attention to, these being features of the girl's face and her hair. (The line work of her neck and shoulders is similar to that of the background.) The whole drawing has been rendered in pencil, but here the weight of the pencil has been modulated. The change in pressure, and therefore blackness, is especially apparent around the eye, upper lip and the strands of hair in the fringe. The hair that is escaping from the tie-back has been drawn with a sweeping motion of the pencil. It has been drawn confidently because careful drawing of the ear and jawline had already taken place.

Compare this informal portrait with Marszalek's other drawing on page 175.

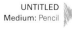

UNTITLED
Medium: Pencil

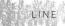

Planning

PAUL HEASTON

A roughed-out pencil drawing is the foundation for this black fineliner and white gel pen drawing. The darker tone of the paper means these indicator lines can't easily be detected. It would be difficult to draw the posed figure with such precision and exactitude straight off. The preliminary sketch has helped Heaston position the figure on the page, helped make decisions about how the model's limbs lie, determined the outline of her body against the neutral backdrop, and indicated how the fabric folds beneath her.

Having said that, Heaston hasn't been a slave to the pencil work. This piece isn't merely a pen drawing over a pencil one. Throughout the pose he has continued to observe the model, to find nuances and details in what's before him. A steady, continuous line describes the edges of things, while vertical hatching has been used to describe form.

It's worth remembering that although a fineliner pen is a good, basic piece of drawing kit to have, it doesn't have nearly as much of a tonal range as pencil or charcoal have. Variations of pressure don't particularly change its flow, and it can't be smudged to create tone.

What Heaston demonstrates here is that even knowing the limitation of the medium – a constant black line with a width dependent on the size of the pen you choose – one can still create, through use of line only, an illusion of tonal shift, and therefore form. The use of a white gel pen to put in the highlights cast on the model from the studio lights makes that illusion of 3D even more successful.

RECLINING FIGURE
Medium: Fineliner, white gel pen

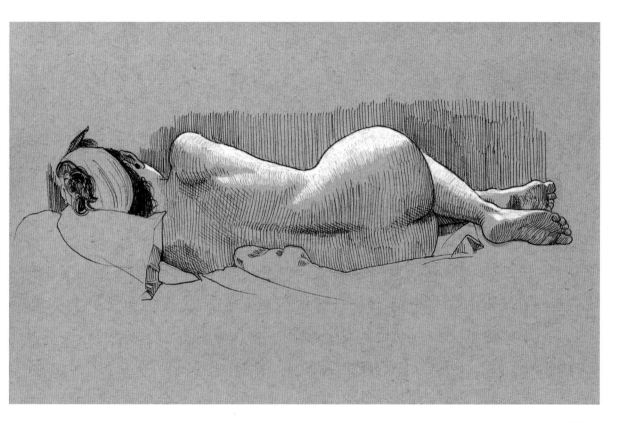

Marker pen

PAUL RICHARDS

Much of the drawing Richards does now is still influenced by a class he took many years ago called 'Life drawing with movement'. Some of the drawing exercises he experienced there involved drawing from a model whose position changed often – at times every thirty seconds. A long pose was just two minutes.

Short poses force you to focus your attention. They don't allow any attention to detail. That experience has had a long-lasting effect on the artist. He's now in the habit of working quickly and loosely. He refers to these sketches as 'scribbles'. The mark-making is fluid and uncontrived, producing a valid shorthand that sums up the pose in a moment. The artist describes them as 'reductionist in approach, eliminating all superfluous matter, keeping only an essential expression'.

These gestural drawings have been drawn with a thick permanent marker. We can quite clearly detect the movement of both the artist's hand and his eyes in the clear pathways of the black graphic line. A marker pen is one of the most unforgiving pens to draw with. Once the mark is down, it can't be modified or erased. It needs to be used in a confident and exacting manner. Richards describes it as being 'brutal', but says that it encourages him to 'see the model in the mind's eye'. He edits the drawing in his mind in advance, before committing marks to paper.

Interestingly, Richards has set himself a further challenge by drawing the seated figure with his left hand (he's right-handed). The line is slightly thicker. This is because the passage of the pen over the paper was slower, and therefore the paper soaked up a little more ink.

UNTITLED 3 & 5
Medium: Permanent marker

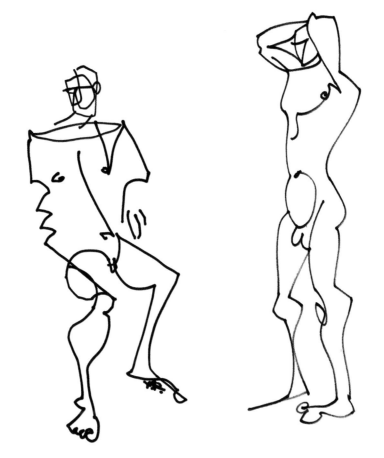

Analogue and digital

EKATERINA KOROLEVA

Koroleva combines various analogue and digital techniques in this portrait. The drawing depicts the model with an elongated neck and no discernible shoulders, making her seem more like a mannequin. This presentation of the figure imbues the drawing with an illustrative sensibility.

Koroleva specialises in drawing female portraits. They are constructed using traditional media – typically sketchy pencil and pen strokes with colourful watercolour backgrounds, combined with digital manipulation. Her use of digital media means that the works can be constructed in layers and edited to a greater extent than if they were purely analogue. The watercolour layer you see here might only exist in the digital version.

Three basic pencil weights combine in this drawing. The lightest lines loop at the cheek and add a mask-like edge to the face; they indicate the form of the head and some strands of hair on the crown. No effort has been made to disguise or erase these indicator lines; they were the foundation upon which the next sequence of lines was drawn. The plait has been drawn using a medium line; it is much the same thickness as the silhouette line of the face. Heavier and more robust black lines depict shadow at the nape of the neck and fringe, and pick out the eyelashes and lips.

Consider using Faber Castell 9000 Jumbo pencils in your drawings. They have an extra-thick, oversized graphite lead and are available in different hardness grades. Try 2B, 4B, 6B or 8B.

JOUER
Medium: Ink, watercolour, digital

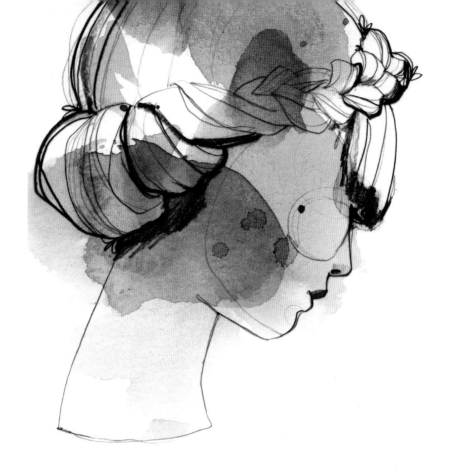

Handmade paper

ELINA MERENMIES

There are many different types of paper one can choose to draw on. Paper size and format can determine how we choose to draw; its absorbency can influence the types of materials we choose to apply to the surface; its expense can make it feel special (or, negatively, inhibit us). An expensive paper is more likely to be so because it is handmade and/or of archive quality. Both of these factors can be very important if you are a professional artist. They imbue the paper with a level of quality that we are not often that mindful of. The consistency of a favourite type of paper can make it a joy to work with, and if a drawing is going to be exhibited or purchased, you'll need to consider your paper's longevity as well. (This drawing is in the collection of Helsinki Art Museum [HAM], Finland.)

Merenmies is a professional artist. In addition to the above, for her the feel of specific materials – here handmade paper, drawn on with ink, pen and brush – is extremely important. The way the material spreads, its particular characteristics and movement in a drawing, are crucial. Merenmies talks about the application of ink as 'now or never, you can't take anything away. Focus is needed so it goes down like it should – like performance.'

The subtlest of outlines provided a guide for the dry brush that swept back and forth across the paper. Decisions had already been made as to where the tonal variations would be. The back of the head was the start of the brushstroke, when more ink was on the brush, therefore the deposit of black is heavier and the tone darker. The same goes for the shadows of the brow and eye socket. Even though the ink is so black, variations in tone are suggested by the spaces left by the brush.

Handmade papers to consider include cotton rag papers, such as Khadi, or fibre-based Lokta paper. Look specifically for paper with acid-free properties.

BEAU
Medium: Pen, brush, ink

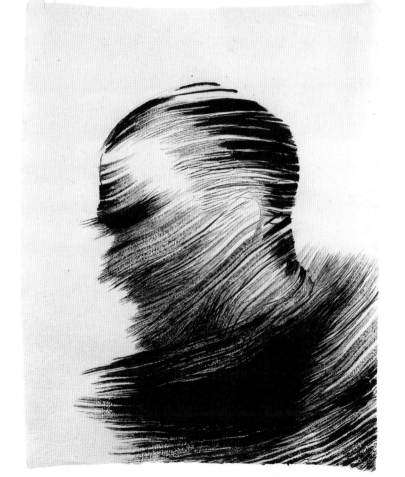

Preparation

How often do we take stock of our regular haunts and consider using them as the subject for our attention? Here, a window inside a favourite restaurant of the artist provides a glimpse of those working there – mysterious figures behind frosted glass, bustling around in this blue-lit room, furiously producing tray after tray of handmade dumplings. Though they are constantly moving, the repetitive actions of the restaurant staff mean that certain positions will repeat enough to be captured in a drawing. Holmes has realised that the natural framing of the window provides an excellent composition for the study. Its landscape format has decided the orientation of the paper.

This pencil and watercolour drawing was completed in the restaurant. The artist is familiar with how busy the space gets, where best to set up, what equipment to take. He planned his visit.

Working with watercolour requires a little more thinking through; water, brushes, paintbox and palette are all needed. This artist decided to work on a good-quality, sizable piece of watercolour paper – 400-gsm cold-pressed cotton rag paper. That meant a drawing board, too; for the paper not to cockle with the addition of wet media, it needs to be stretched. A pencil sketch using a propelling/mechanical pencil captured the dumpling makers working. Transparent watercolour washes – working from light to dark, and from larger areas to smaller – completed the image.

The artist went one step further with this drawing – he recorded himself doing it. You can find the video here: vimeo.com/31158462.

THE DUMPLING MAKERS
Medium: Pencil, watercolour

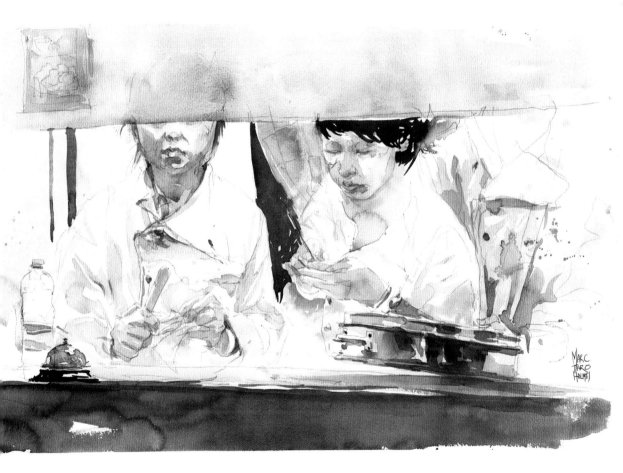

Brushwork

MIRCO MARCACCI

The artist concentrates his attention on one part of the figure. The drawing-cum-painting is a study of a male model's chest. The torso seems dismembered – head missing, body cut off at the waist, with nothing below the model's forearms.

The pose itself is one of curves – the shoulders, chest muscles and ribs. Although we can't see his back, we know it, too, is curved as he bends slightly towards us. Is he at rest or are his muscles tense? It's difficult to tell.

The roundness of the pose has been captured with black pen line and then brush work that is much more straight line and angular than one might expect for an organic form. Some continuous line drawing isn't so much a constant flowing line (producing a more sinuous line outcome) as a stop-and-start technique. In this instance, the medium remained on the paper in between observation of the model and making the next mark on the page, but decisions were made a little at a time, so subtle nuances of outside edge were captured. The artist was making sure that his scrutiny of this male subject was accurate.

With pen outline, some of the stomach muscles, and areas of intense scribble work complete, Marcacci has then added slabs of rectangular black tone with acrylic paint and a brush, and in turn, over-painted these with white acrylic to modulate the effect of light and shade. Fingerprints and drag marks add to the expressive nature of the outcome.

CHEST 031
Medium: Pen, acrylic

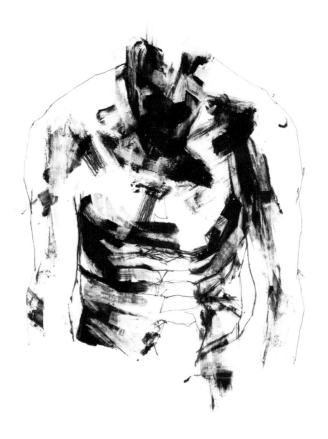

Tonal washes

This Conté crayon and ink wash drawing is aptly named, because the quality of light the title refers to is well captured. The sun shines in from the right. The model's face is brightly lit on that side and in deep shadow on the other. The resulting high contrast is ideal to prompt the use of a technique like this.

This is a very well-handled study using predominantly wet media. The blooms and washes of ink have been achieved using a technique called wet-on-wet. It's a study of tone/value in greyscale – a range of grey from pale through mid-tones and on to black. The ink has been laid down with a brush in a sequence of washes, each of which is progressively darker. Because this is a translucent medium, it's always worked light to dark and not the other way around. (Note that you should use watercolour paper for this technique.)

Decisions have had to be made before brush is put to paper. By studying the fall of light on the model, Horst has worked out how many tones/values of grey he will need to complete it. The paper itself is the lightest tone. The next in the sequence is the pale grey on the model's left side, after that the shoulders and some of the facial features, and finally the blackest tone – the model's hair. The artist hasn't waited for the paper to dry between washes, so they bleed into one another in places. By utilising that mix and allowing drips to fall the length of the portrait, the surface play is much more interesting.

Note how Horst has used the most minimum of Conté outline. The face has no outline at all on the brightly lit side, and yet we can make sense of it.

ONE BRIGHT MORNING NO. 1
Medium: Ink, Conté

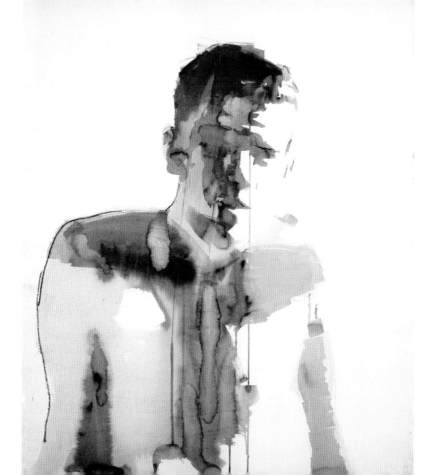

Dominating the space

SYLVIE GUILLOT

A huddled-up figure can be read in different ways; objectively this is a model in an interesting position, but subjectively this is one of the most emotive of poses. It's possible to perceive a sleeping form – albeit naked and uncovered – or someone pulled into themselves for more negative reasons. However we read things, this is an arresting composition.

We're looking down at the reclining figure from the head end. The pose is foreshortened. The artist has arranged the curled-up form in such a way that it touches three of the paper edges. It dominates and fills the whole space. A knee and toe line up on the right, the curving back nudges up to the left, while the model's hand seems to grasp onto the lower edge of the paper.

Black Conté pencil has been used to draw the figure. This medium works well on textured paper. Because they're harder than charcoal or pastel, these pencils give a more crisp, solid matt black line. Guillot began with a series of round looping marks that mapped out the space for the placement of the figure. She then defined the form. Look at how the dips and curves of the lower back have been refined from that initial loose sweeping arc. Within the mass of the body itself one can see more sweeping, looping lines. The artist was finding her way around a 3D form and making decisions about how to depict it on a 2D surface. The addition of watercolour completes the piece.

This drawing is on Arches watercolour paper and measures 50 × 65 cm (20 × 26 in). This is a very good-quality paper to work on. It's made from 100 per cent cotton fibre, and it's acid-free, pH-neutral – important factors if the quality of your work means it is of an exhibition standard, like this.

EMMANUELLE HUDDLED UP
Medium: Watercolour, black Conté pencil

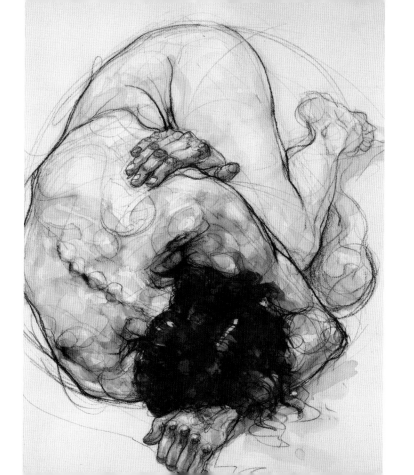

Experimental selfie

This is one of a series of self-portraits completed for a graduate degree show in Art and Design. Cater-Tooby located the photographic material for her drawings from several sources, including her own blogs, family photographs and specially taken selfies. She wanted to explore ideas of representation and stereotyping. The artist was mindful of the reactions her photographic self garnered, depending on the situation in which it was viewed. Reaction on social media, unhappily, was not always positive, but helped her to determine what and how to draw.

The artist's source material was small – passport photo-sized upwards – but conversely, her drawings large. At 59 × 84 cm (23 × 33 in), you would be looking at a much larger self than in a mirror. Like other artists' self-portraits in this book, this self-scrutiny produces strong drawing.

Compare this self-portrait with those by Derek Overfield (page 55), Philip Tyler (page 123), or Mirco Marcacci (page 189). A drawing made from a photograph can produce very different outcomes. The camera provides a 2D image where decisions about light and form are already decided. They are fixed. Quite often the edges of things are unresolved.

The artist doesn't try to disguise the origin of her drawing. She wants you to know it's worked up from a photograph. Black biro outlines are filled with a close diagonal infill and cross-hatching. The mark-making is methodical and labour intensive. Cater-Tooby has been able to achieve a variety of tones with this one humble medium. Masking tape has been used on the surface as a reminder that once you've accepted your flaws, no one can use them against you.

IMPERFECTIONS
Medium: Biro, masking tape

Post-editing

KATIE LOUISE TOMLINSON

If you would like to draw people who are participating in sporting activities, take a minute to consider your vantage point. Your own position can provide an advantage in being able to observe their movement for more than a fleeting moment. By placing herself poolside at the end of a swimming lane, Tomlinson was able to see and capture the repeated actions and rhythms of the swimmer advancing towards her. She gave herself more than one chance to properly observe and record what was happening.

This drawing works really well because of how the figure is isolated asymmetrically on the sketchbook page. The pages of the book become the space of the water surrounding the swimmer. Tomlinson hasn't allowed the gutter of the sketchbook to impede her rendering of the water. Quick sweeps of the brush, blobs of watercolour and blue-black, and areas of dragged ink and water-soluble pencil add tonal depth and a sense of movement to the water. We can well imagine the moment immediately after this one, as the swimmer prepared to take another stroke.

Everything in this drawing looks immediate and as though completed in situ. What might come as a bit of a surprise is that there is some post-editing involved. Some of the blue tones were added after the sketchbook page had been scanned. What was a quick graphite pencil sketch has been transformed with digital brush marks. The flesh tones of the swimmer have been similarly added at a later stage.

SWIMMER
Medium: Mixed media

Photo as reference

DENISE NESTOR

Pre-photography, portraiture was only for those who could afford it. Portraits were commissioned pieces of art – not just a record of what someone looked like, but a statement about the sitter's qualities, depicting things such as wealth, power, status or beauty. Now, the commissioning of a portrait is a much rarer thing. Artists are more likely to use those known to them, and to draw them in whatever pose or style they choose.

There are several drawings in this book where the sitter is well known to the artist. This is one of them. It cleverly combines aspects of formal portraiture with an informal photographic snapshot approach. The sitter peers out at us informally. He scrutinises us, his head turned slightly to one side, eyebrow raised and with a direct and quizzical gaze. His hair, semi-beard and clothing are all very relaxed.

Formal components of the drawing come with its composition. The man is placed in a measured way on the page, and any distracting background is stripped out. Placing him centrally in a plain, uncluttered space means we focus solely on him. The even closer attention to detail that the artist achieves using graphite pencil reveals a deep understanding of greyscale tonal values – white through black. The red diamonds on the man's jumper counter the greys in terms of a shock of colour, in addition to the cruder way that they are rendered.

A detailed pencil work like this would not be done completely from life, i.e. with the sitter present. A series of photographs would aid its rendition.

JAMES
Medium: Pencil, coloured pencil

Kraft paper

SYLVIE GUILLOT

These drawings have a historic sensibility to them. They look like they could be academic pieces from an atelier, their aim being to practise the drawing of muscle and body mass – some of the fundamentals of human anatomy. The sepia tone of the paper and apparently traditional use of black, white and sanguine (red) chalks add to that assumption.

Ateliers, or workshop studios, were training places for artists where various methods of representational drawing and painting were practised. They traditionally included sessions of life drawing. Students in them were expected to understand the musculo-skeletal make-up of the human form.

We're not expected to have the same kind of knowledge nowadays. What's important is interpreting what we can actually see. Guillot set the positions of the model to best capture physical tension, and therefore accentuate muscle definition. These would not have been easy positions for the model to maintain for long periods

of time. (Note that many models will not have well-defined muscles. The muscle definition of athletes or bodybuilders is only going to be important if you specialise in more extreme depictions of the human form – superhero comic books, for instance.)

These are big drawings – each 75 × 110 cm (29 × 43 in). This is a large space to cover in terms of media and the artist's own physical movement. Guillot has chosen to work on kraft paper, which is ideal for using as a mid-tone in charcoal drawings, as here. She's used pastels and black Conté pencil, too. The paper is ribbed on one side, smooth and shiny on the other (she's chosen the ribbed side). It's a relatively inexpensive paper, though better purchased in a thicker weight (i.e. 140 gsm). Designed for packaging products, it has strength and durability and is ideal for large, bold work.

TENSION 2 – MICHEL, TENSION 5 – MICHEL
Medium: Charcoal, pastels, black Conté pencil

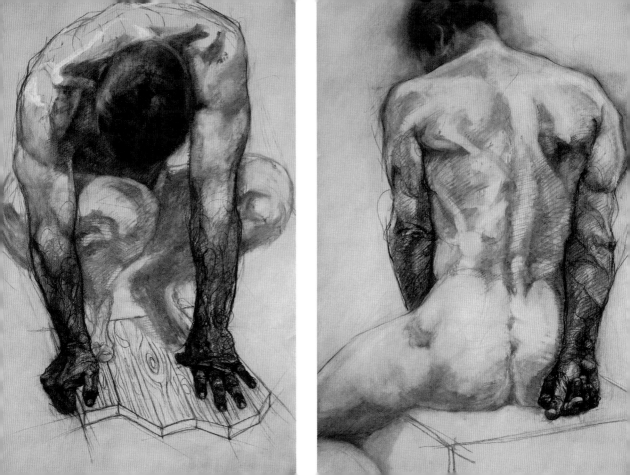

Modulated tone

GAMLET KHOUDAVERDIAN

What's immediately noticeable about this drawing is the texture of the paper. Like pastel, charcoal works very well on a paper that isn't smooth, that has a bit of texture, or tooth. Texture gives these powdery or crumbly media something to adhere to. Having more tooth on the surface allows more medium to be built up. If you're using charcoal, that means a better modulation of tones – from the palest grey to the darkest black.

Pastel papers can be grouped into three basic types: toothy, dimpled and Ingres. This is an example of the Ingres paper. It has a soft texture a little like the surface of fine stationery, where there is a grid of lines indented into the paper. You can see the linear texture each side of the model, particularly where the artist has used the side of the charcoal stick to quickly block in the shadowy background.

Each aspect of the drawing is an excellent example of modulated tone. The artist has used very little line work. It's present as a series of indicator dashes and flecks only, giving clues as to where one tone meets another. The lack of line will always make a drawing seem more three-dimensional, more realistic. Drawing a black line around the edges of objects will make them seem much flatter – a line doesn't actually exist – but drawing in that fashion is the default position for most of us.

If you want to complete a tonal drawing, strong directional light is important. It provides bright white highlights, and black shadows or lowlights. It helps you to see the different tonal zones. Try not to overwork the drawing; allow the paper itself to be the highlights. Remember, charcoal can only give you modulations of grey and black.

NUDE STUDY
Medium: Charcoal

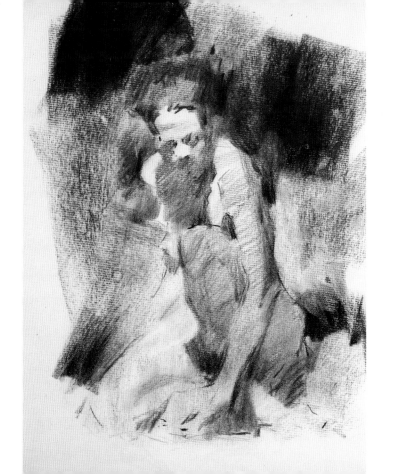

117

Mid-tone paper

YADGAR ALI

This is a self-portrait. It's different to other examples in the book because the gaze of the artist is not directed towards us. Ali looks slightly upwards and into the distance – beyond the paper's edge. We look upwards at him, too. He carries his portfolio in one hand and his jacket in the other. He's ready to go somewhere. He's not particularly interested in us. The portrait is about what this person is about to do.

Ali has chosen not to draw a background. We see only him and what he carries. He's chosen a warm, mid-toned paper. The negative space around him – the paper – is an important part of the composition. It is a less stark choice than the usual white paper one might expect. His pencil work shows up on it much more subtly. The paper has a flecked surface with very little texture (or tooth). This smoother surface is more suited to his choice of drawing medium.

A very sensitively drawn outline has had areas of tone (or value) built up within it using a combination of diagonal marks and cross-hatching. The diagonals are consistently about 45 degrees left to right. Much as the intensity of dots on a newspaper describes light and dark, the modulation of these lines indicates the same here – the closer the diagonal, the darker the tone. The fabric of Ali's clothing is successfully described using this technique. Cross-hatching has been used for the darker areas. Even at its most dense, nothing looks very black. A fine pencil, and the mid-tone paper, play everything down.

PROCESS OF DARK JOURNEY
Medium: Pencil

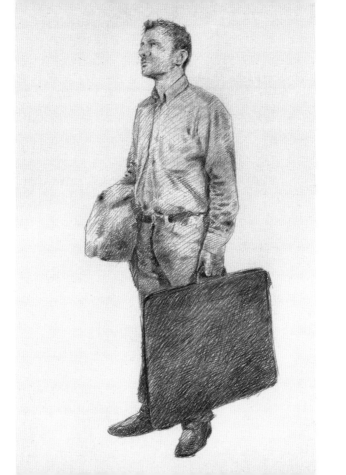

Using video stills

MARK HORST

There are some instances when drawing from life when it's necessary to work from photographs and film stills to capture the moment you're after. Elements of this drawing have been sourced from a YouTube video. Horst has been attracted to the potential of certain poses in the video. For reference he's paused, freeze-framed/screengrabbed and saved those poses he can combine into a new image. There is no one moment in the video when these three breakdancers appear in this configuration. The artist has completely rejigged the figures' setting to make for an improved composition.

It's difficult to say what might attract our attention or why. Taking time out like this to really study one small part of a myriad of daily-consumed videos, films, photos, advertisements, etc., is a really good idea. It slows things down, makes us scrutinise things more closely and put our own twist on things.

Here, elements of a short video have been transposed using pencil marks. Horst has made a high-contrast drawing. He's decided which extremes of the tonal scale to render – key elements of either black or white. The paper itself is the light tone, the pencil rendering the other. This kind of tone/value simplification is often used to make stencils.

The pencil marks have all been filled on the diagonal, some of them almost scribbled into place. There are no pre-drawn outlines. This suggests a process not revealed in the drawing itself – perhaps use of a light box or multiple-layered tracing from a projection.

STUDY FOR ALBUQUERQUE BREAKDANCERS
Medium: Graphite

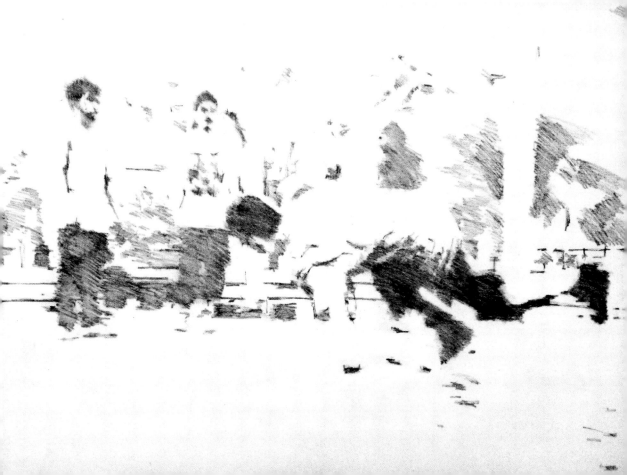

Expressive mark-making

PHILIP TYLER

Charcoal is a mainstay of the figurative artist. It is one of the first materials one uses in any life drawing class. In this drawing there are two types used– vine, or willow, charcoal and compressed charcoal. It's important to know the difference between the two.

Willow charcoal makes a lighter mark, smudges easily and can be erased away easily. It is usually purchased as a bundle of irregularly shaped sticks. It is quite literally burnt organic matter with nothing added. Compressed charcoal gives a much blacker, denser mark. It adheres to the paper surface much more than the willow variety, and can be very difficult to erase. It is made up of powdered charcoal held together by a gum binder. It comes in a variety of shapes – as a square or round stick, or as a pencil.

Like other artists in this book, Tyler regularly draws self-portraits. For him, they have been a recurring theme since art school and often result in oil paintings. Charcoal's easily blended, erased, manoeuvred

characteristics mean that it is closely related to painting, making it an ideal exploration, practice and preparation-study medium.

A heavier duty paper – 220-gsm cartridge (acid free) – has been used here. The weight is important. This portrait was drawn with considerable energy and speed. The paper needed to withstand that robust approach. The artist is exploring notions of his own loss, grief and despair, expressing them with powerfully made marks. One can sense the rendering of the strong black areas as physical movement, and imagine the speed of the zigzags under the chin – the smudged and erased areas of the face being achieved similarly. Tyler works and reworks his drawings many times before being satisfied.

STUDY FOR EDWARD ST 1
Medium: Charcoal

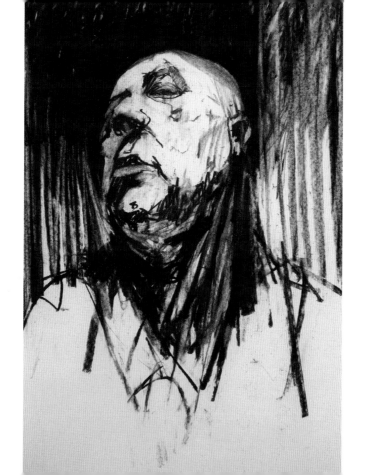

Restricted media

Nothing is quicker than taking a selfie. With camera at arm's length, we look up at ourselves, and . . . click. Done. Inevitably, something this easily come by is immediately disposable. Thurlow takes this new portrait format and runs with it. However, he makes it much less of a throwaway snapshot by investing time in it, reproducing it as a finely rendered pencil drawing. He inspects things closely. His attention to detail and accuracy make us take notice.

The gaze of the model pulls us in, too. Unlike several other portraits in this book, he's looking up at us while we look down at him. This swapping of the viewer's position is the difference between the self-portrait drawn from a mirror's reflection and one captured with a camera phone. We have become aware that a photo taken like this is more flattering, and that it is more social media-friendly.

The face and its expression are predominant in this drawing, as they should be for a work to properly be called a portrait. It's been composed to fill the page. We can see Thurlow's careful line work on the shirt fabric and the model's hair. Only the face has been treated to a full rendering of tonal infill. It's clear what we are supposed to engage with and scrutinise within the image. The drawing was done using 0.7-mm pencils and a propelling eraser. This restriction of media helps focus Thurlow's creativity. For him, these are tried and tested tools. Things don't have to be complicated.

Note: a 0.7-mm propelling pencil draws with a wider, softer line than a 0.5 mm, making it ideal for filling and shading, and the lead is less likely to break. 2B or softer is best; HB would be too hard. Propelling erasers come in various widths, too. Choose the one that allows you the most precision.

SELFIE – DAVE
Medium: Propelling pencil, eraser

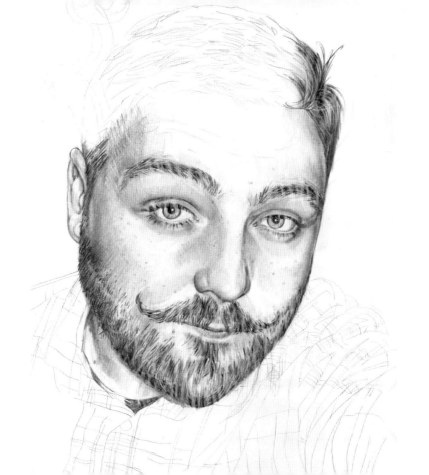

Ambiguity

MARIA MANTELLA

The reading of this is quite ambiguous. We could be looking at an adult from a slightly raised position, or we could be looking at a child on the level. If our view is from above, it is the foreshortening of the figure that makes it look smaller. If this is a child, it is the proportion of the head in relation to the body that suggests so.

It's important to understand the concept of proportion when drawing the figure. Proportions change relative to age. As a general guide only, an adult stands seven to eight heads tall full length. In this drawing, if our perception is that this is a child, those measurements alter. The head is a quarter of the figure's full length, i.e. it fits into the body four times. This might be the proportion of a two- to three-year-old child.

In my mind this is a young person. The figure is stationary, the one foot we see braced to take the weight of the forward-leaning posture. I see someone wearing a backpack. I think they're playing a hand-clapping game with a friend we can't see. This feels like a drawing made during a child's playtime. It seems to capture movement. Look at how the arms and hands are drawn and redrawn.

The more solid areas of pencil work shift between shades of grey. They appear to signify hair, clothing, but could be another overlaid form, too. Intriguingly, this drawing is called 'Panthalassa'. This is the name of the vast global ocean that surrounded Earth's ancient supercontinent, Pangaea, many millions of years ago. Could the drawing of those various grey areas, the movement of this child, also be a metaphor for that ancient geographical phenomenon?

PANTHALASSA
Medium: Pencil

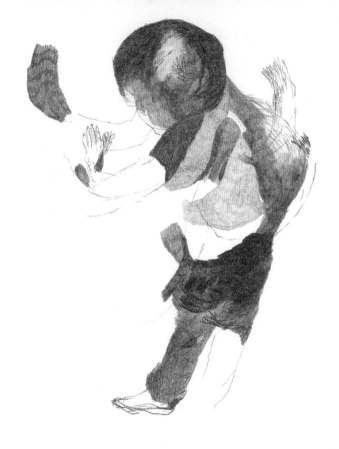

Vignettes

YADGAR ALI

A vignette is an image that typically fades into its background without a definite border. It is a commonly used device for framing small drawings or photographs. The vignette is a useful device to apply to drawings you might wish to have an illustrative or intimate quality.

This impressionistic drawing was made of a journey taken by the artist. The small, enclosed space in which he travelled is echoed by the diminutive size of the paper he has used. The drawing does not use the full extent of the paper surface. It falls short of the edge. There is a suggested border on all sides over which the drawing hardly strays. In effect, the framing reduces the image even further. We are led to focus on an even more intimate space by this framing device.

The drawing utilises a mark-making technique that delicately loops and swirls on the surface. The layers of black pen depict a tonal depth in the small space. People look out of the space they are in, gazing at us enquiringly. The vignetting of this journey scenario gives the image an illustrative quality. It seems to exist to tell a story. It captures a brief moment, a fleeting but important instant for the artist.

DARK JOURNEY 2
Medium: Pencil, ink

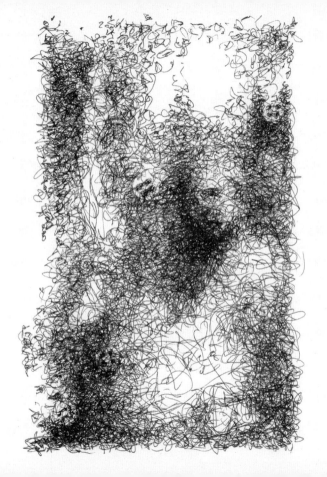

Simultaneous drawing

MARILYN KALISH

One of the best pieces of advice I ever received at art school was 'don't work on just one idea at a time'. At the time, the statement bewildered me. I thought drawing (and other making) was a linear experience – the idea arrives, you collect your materials, make the piece, finish it and move on to the next. This rhythm of working is fine if things go smoothly. They don't always!

One of the most successful life drawing classes I've taught involved asking students to produce multiple drawings simultaneously – except, I didn't state this at the get-go. Students each placed three large sheets of paper on the floor. I told them the model's pose would last thirty minutes and, using thick willow/vine charcoal, to start drawing. Using random timings within the allocated half hour, I asked them randomly to switch to the next sheet, and the next in rotation. Initially there was resistance to the task – 'It won't be any good; there's not enough time' being the common cry of despair. Eventually the process took over.

Kalish often works on several pieces at the same time – sometimes eight to ten. For her, allowing things to flow in an uninhibited, expressive manner is of great import. She perseveres with sequences of drawings. If she gets stuck, she moves on to the next. This way of working can be prolific.

When producing large series of drawings, the need to edit becomes important. The students were surprised at how successful most of their drawings were. They kept their sequences of three as a record of the exercise. A successful artist needs to be mindful of continual reassessment so that strong drawings like this emerge from the process.

CHANGED, UTTERLY
Medium: Charcoal

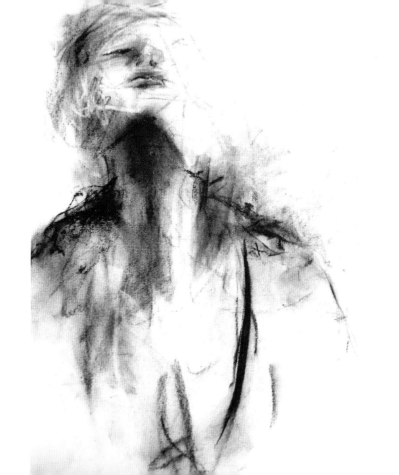

Consistency

PAUL HEASTON

Famous artists have often been said to have found their muse when the work they produce is not only a record of their subject, but has been inspired by the sitter. Working from the same model time and time again is a common trait in figure drawing. Visual familiarity with a subject encourages development of ideas. Getting to know the form of your model means that your drawings can develop over time. The habit can often speed up the drawing process.

Heaston makes many observational drawings of his wife; this is one of a series, made as they awaited the birth of their child. Comparative studies – the making and placing of drawings with similar subject matter – tend to encourage a visual curiosity in the artist (or viewer); it's natural to look for and find sameness and difference in sequences. Simple questions arise. What habits change? Is the subject in the same space, in the same pose? How have the drawings improved?

In terms of visual language and media use, one tends to look for consistencies and inconsistencies, even within narrow parameters, when presented with a set of similar drawings. This may be something as subtle as the tone of the paper used, or the size and make of a sketchbook. The compositional weight of Heaston's series errs to the left-hand page, where Heaston's wife has been placed busily crocheting whilst sitting comfortably. Each of the drawings in the series is consistent in its use of fineliner pen, and a shading technique that explores vertical hatching, or cross-hatching. Some place the sofa face-on, others at an angle – so lengthwise perspective is dealt with (or not) – and so on, and so forth.

LINDA CROCHETING 1 & 2
Medium: Fineliner pen

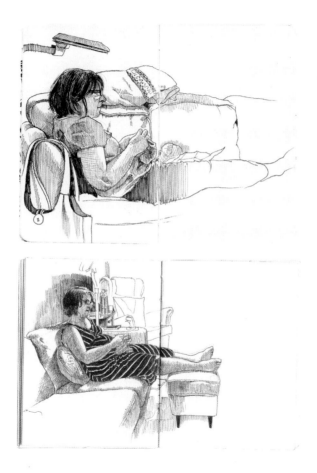

Large-scale work

Developing quick sketches of the figure and drawing self-portraits, or the portraits of others, are important parts of Reedy's studio output. They are also important practice and planning for his very accomplished paintings. He regularly draws from a model. He teaches life drawing, too – see the student demonstration drawing he made on page 39.

A drawing session is often used to try out several different poses, ideas and timings. This drawing began as a portrait; we see it partly revealed to the left. In the limited time available, Reedy has also drawn a reclining nude in a foreshortened position. It's unusual to see two drawings of the same model combined like this. It's very effective. A consistency of material use means that the drawings read as one.

This drawing, at 105 × 75 cm (42 × 30 in), is one of the largest in this book. It's drawn on Utrecht American Master's Paper – a soft, flexible paper which is available as a 1.3 × 9-m (50-in × 10-yd) roll. You can cut it to the size you need. Working at this scale, charcoal is best. It allows for quick coverage.

Charcoal comes in three forms: vine/willow – good for the early stages of a drawing because it is the least permanent and easily (re)moved; compressed – for the truer black tones/values; and pencil charcoal for details. This drawing is particularly effective in creating a contrasting range of light and dark – a method called chiaroscuro. A putty/kneaded eraser (soft and pliable) and a gum eraser (crumbly) have 'brought back' some of the highlights using a method called reverse or reductive method drawing.

RECLINED
Medium: Vine charcoal, compressed charcoal, pencil charcoal

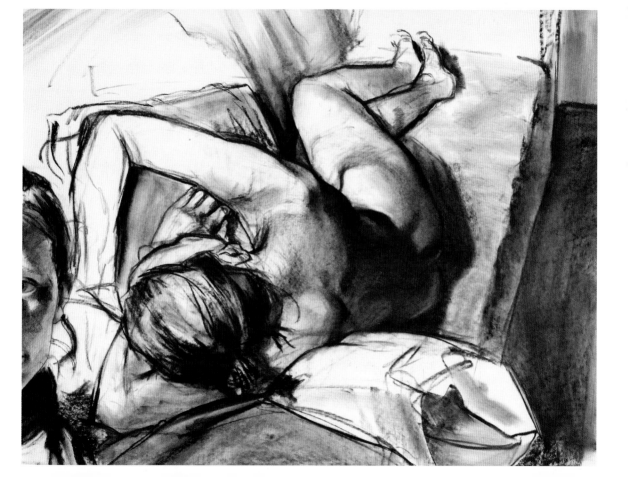

Foreshortening

PAUL HEASTON

When a model is in a reclining position like this, certain viewpoints of the pose are much more complex to draw. Capturing the full length of a model when you are positioned at either the head or feet looking along the length of the body is the most difficult. This is because you are looking at a 3D form, but trying to draw it on a 2D surface. In order to get the proportions right, you'll need to have some understanding of the rules of foreshortened perspective.

You'll know if there is any degree of foreshortening, because as things get further away from the viewer they appear smaller. An example of this is the model's foot in this drawing. Conversely, consider how large the model's head and elbow seem because they're nearest to us. The figure is not scaled evenly. Foreshortening is an optical illusion or trick. It causes the distance of the body to appear shorter than it actually is, because it's angled to the viewer. The model's mid-section is particularly affected by it. (See also the foreshortening of Sylvie Guillot's 'Emmanuelle Huddled Up' on page 107 and Michael Reedy's 'Reclined' on page 135.)

Any uprights or natural verticals are helpful when working out where to start. Here, that's the model's right leg. Usefully, it's roughly parallel to the right edge of the paper. Look at the guideline beneath her right heel and lower back. Heaston was finding the correct angle to work to. Once this is established, incremental measurements can be taken. One method is holding a pencil at arm's length with one eye closed, measuring the distance between parts of the body. This method is called sighting. It's only when measurements are correctly established that any tone should be added. It would be difficult to erase this blue pencil.

RECLINING FIGURE 6
Medium: Blue coloured pencil

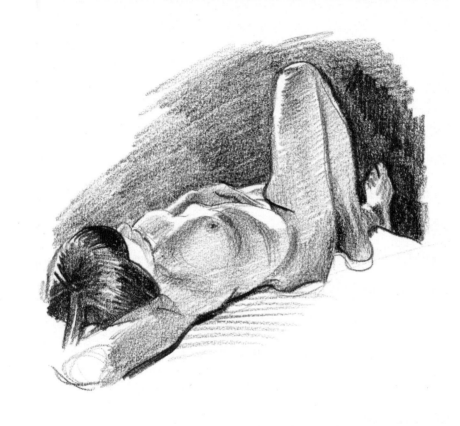

Illusion

YADGAR ALI

Three people sit around a table. They might be chatting, or perhaps playing a card game.

What we're seeing is an illusion. This is actually the same model repositioned three times. Using the horizontal line of the table top as a constant – as something that doesn't move at all – it's possible to draw the model in multiple positions. (See also Bryce Wymer's bathing drawing on page 83.)

By using charcoal and eraser – a malleable drawing combination – the artist can push and pull marks across the surface – an important factor when adjustments to the drawing will need to be made. If you want to try something similar, begin by covering your paper with charcoal. Use it sideways-on for quick coverage, blending it with your fingers, a paper towel or a cloth. This will leave a residue all over the surface for you to work with. Use willow/vine charcoal for this, as compressed charcoal is less easy to shift around. This

is not a process you have to be particularly careful about. It can be easier to do at an easel because extra charcoal powder will fall away easily.

The drawing is done with an eraser, which needs to be hard enough to shift the charcoal. A plastic one is best. Its small rectangular shape is easy to hold and control. You can see how it has been used here to bring back the white from the black – a reverse method of drawing. Charcoal has been used to pick out the blacker areas and define lines. As the model moved, any overlaps of form that didn't make visual sense could be blended back into the surface and redrawn.

DRAWING STUDY (5)
Medium: Charcoal

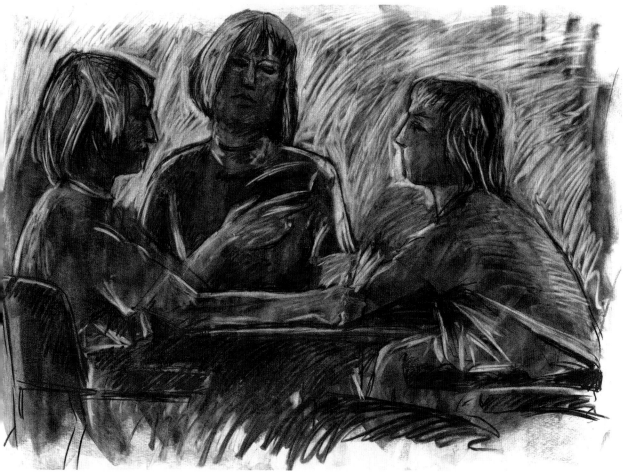

Digital sketch

MANUEL SAN-PAYO

San-Payo is a prolific sketcher of people both on paper and digitally. This drawing is one of his digital sketches. Because this was drawn on an iPhone, the format of the piece seems exaggerated. It's longer and thinner than we might expect. Format refers to the proportion of the surface length in relation to its height. If this was paper, we might choose to trim it to a standard size; as it's drawn on an iPhone screen, the emphasis is on drawing to fit the limited space available.

Consider the size of a phone. The image printed here isn't that much larger than the screen. It's likely that the digital drawing is oriented this way – portrait format – because that's the easiest way to hold the device.

The beauty of working like this is that you're likely to have your drawing tools on you at all times. San-Payo uses the Vellum app to draw with. It's one of the more pared-down drawing apps, stripping things down to the essentials – it makes lines, interesting textured lines – that build up into tonal layers, and it smudges and erases. This makes it deceptively easy to use – almost as easy as picking up pencil and paper, except it can also make marks resembling charcoal, Conté crayon and ink.

The artist's subject is someone he often draws. One can almost imagine him saying to her, 'Don't move, stay exactly like that.' She's obviously used to the request, resting on her hand, aware that the digital sketch won't take too long.

ANA
Medium: Digital

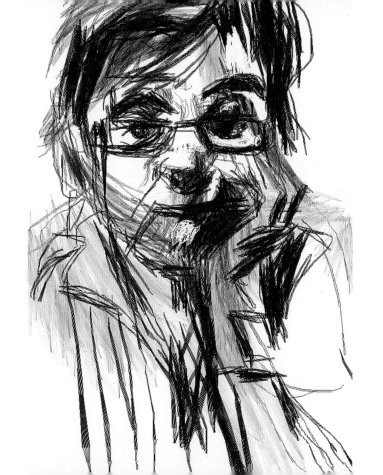

Sepia

PAUL HEASTON

A sepia-toned image always seems imbued with a sense of yesteryear because of the way we associate it with old photographs. In drawing terms, this red-brown colour has been around much longer. The term sepia, when properly used, refers to the brownish-black ink made from the dark liquid of cuttlefish. It is often used to describe Old Master drawings that were actually drawn with iron gall ink, which turns from black to brown with time. (Iron gall ink was the usual ink used for writing and drawing in Europe from about the 5th to the 19th century. It remained in use well into the 20th century.) Although historic precedents can influence our decision to choose brown ink in contemporary times, it's now much easier to use these warm, earthy tones! Here, Heaston has chosen a sepia fineliner.

This drawing gives us a greater sense of the set-up of a life drawing class. The model isn't isolated from what's happening around her; she's part of it. The scene is typical of the utilitarian world of the life room. A modest dais has a sheet thrown over it. Atop that is an ordinary folding chair. Another sheet softens the chair's harsh structure. The model leans back, one leg crossed, gazing into space.

The artist opposite is revealed, working on a large drawing board. It's oriented to a landscape format (wide rather than tall). We can imagine the composition on it. Note how the board rests on an impromptu easel – the back of another chair.

Heaston didn't need an easel. He chose to work across two pages of his sketchbook, unhindered by its gutter and stitching.

SEATED FIGURE
Medium: Sepia fineliner pen

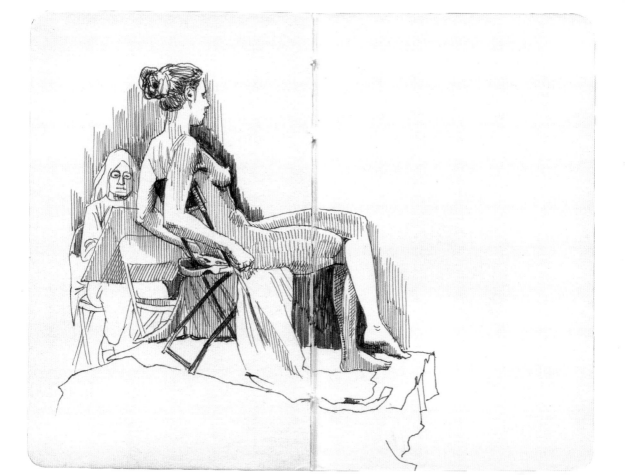

Charcoal modulation

MARK TENNANT

A loosely drawn charcoal pencil sketch determines the positioning of the head and shoulders of this female model. The pale grey tone of the paper suggests that its white surface has been prepared for the charcoal work to come – by lightly dragging willow/vine charcoal or spreading powdered charcoal over the paper surface and rubbing it in with a soft cloth, paper towel or mop brush, thus toning down its bright starkness.

Charcoal held lengthwise against the paper has almost effortlessly been used to portray the recesses of shadow and texture of the hair. Tennant has made broad sweeps with the charcoal to render shoulder, neck and ear. The guidelines placed previously haven't necessarily been adhered to, and yet these tonal sweeps make visual sense. Elsewhere, Tennant has left areas unfinished or entirely absent. Highlights merge into the negative space surrounding the model, separated only by the originally drafted outline.

The lighting of the life studio has meant that the tonal range cast on the model could be precisely managed. The result is a contrasting range of highlights and shadows. Mid-tones have been minimised. The model focuses beyond the frame of the drawing – the direction from which the light source is coming. The darkest tones on her face have been finely modelled. See the shadow under her right brow, beneath her nose, under her upper and lower lips, even her eyelids. Nothing has been overworked. A quick fleck of highlight on lip, nose and eyelid has been provided with an eraser. The same treatment of the eyes provides their glint and truly brings the portrait alive.

JAIME
Medium: Charcoal

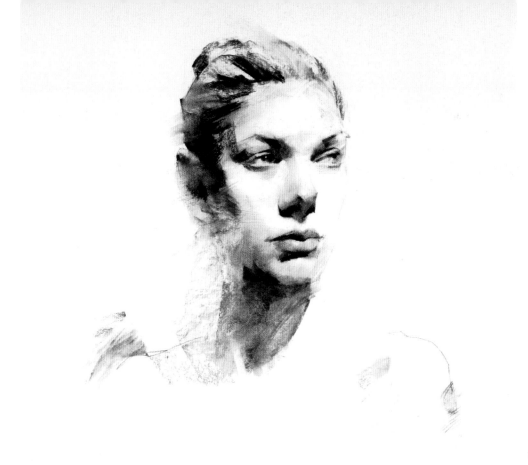

Cropped composition

Choosing the right paper for your drawing depends on your medium and intended working methods. This is a charcoal drawing, so one can assume paper with a certain amount of tooth is best. Tooth refers to the texture of the paper surface. It drags particles from the charcoal stick or pencil as you draw, and holds them to the paper.

This drawing has been made on Ingres paper. It's a good paper to use, as it has a toothy grain of close lines on one side and a mottled surface on the reverse. Dvorak has used the side with the subtle close-line texture in his drawing. Laid finish refers to the imprint of the regular screen pattern of a papermaker's mould. This mimics the paper used by the Old Masters, including Ingres himself, from whom the paper takes its name. This paper is available in many colours. A warm tone has been selected here.

What's immediately noticeable about Dvorak's work is how the whole figure isn't placed within the frame of the paper. He's purposefully chosen to focus on a composition that omits the head and shoulders plus much of the width and length of the model. This cropping of the image helps us to assume a closer scrutiny of the hands and foot. These are what the artist deems important for our attention in this study. (Compare with Sylvie Guillot's compositions on pages 107 and 115.)

Drawing off the edge of the paper is difficult. The movement of charcoal back and forth will snag on the paper. Using masking tape all around the edge – half on the paper and half on the drawing board – will help prevent this. Alternatively, you can trim your paper to a preferred composition after you've completed it. Framing with a camera's viewfinder/screen can help decide what this might be.

UNTITLED FEMALE NUDE 3
Medium: Charcoal

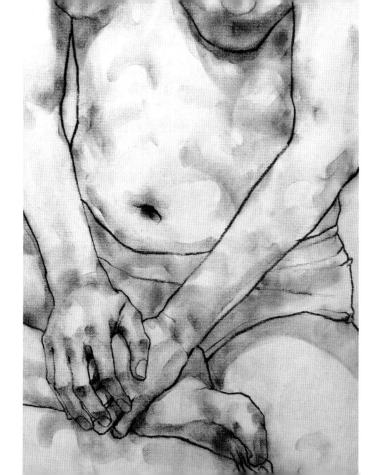

Contrasting elements

MARTÍN PALOTTINI

Subtly defined tonal work and more rugged, ripped paper collage are combined in these drawings to great effect. The artist's aim was to build a bond between opposing components – something he describes as 'academic technique versus expressive'.

These drawings are on large sheets of 200-gsm cartridge paper – a multi-purpose paper that is robust enough to be able to erase and alter pencil work without damage to the surface. Here it needed to be able to withstand the application of wet media (white paint), the adhering of collage pieces and the addition of embroidery, without distortion to the paper surface.

The drawings began with meticulous, time-intensive drawing of the models' faces using pencil. Because the drawings are large but reproduced here much smaller than in their original state, the tonal values seem even smoother and more finely modulated. Palottini has countered this 'academic' drawing with the

introduction of roughly torn sheets of gold and brown paper. They have not been attached flatly but with creases, torn edges and overlaps to the finer pencil work. White paint encroaches upon the pencil work of the models' heads, and the gold paper has had streaks of white paint dragged across it, making it appear like folded fabric or leather.

The models' hair has been drawn with water-soluble Graphitone. These graphite sticks are paper-wrapped, and can be used like a graphite pencil or peeled back to create broad sweeps of tone. Palottini has added water to the graphite in parts, dissolving the line to create a flowing wash.

THE OTHER SIDE I & II
Medium: Mixed media

Using new drawing materials

KAREN DARLING

Traditional and new components combine in this drawing to great effect. The artist has used gestural drawing to plot out the twisting pose of the figure. We can detect the movement of Darling's pencil as she moves from the head, down the curve of the spine, turning quickly to place the leg. The arm is embellished with a spiral to signify the elbow. Hand and foot are mere suggestions. Nothing is overworked. No unnecessary detail is added. These are classic components of a gestural drawing, which is direct thought and physical energy combined. It is an exercise in seeing. Hand and eye work together to define the general characteristics of the subject. Consider how few marks actually capture the shape, weight and twist of this model.

The new components of this drawing are the materials the artist uses. The surface is TerraSkin, which is made from mineral powder and resin. No water or tree fibre is used in its manufacture. It doesn't absorb liquid drawing materials like regular paper, so mark-making can stay crisper. It's water and tear resistant, too.

This is useful, as the blocked-in larger areas of this drawing were done using Derivan Liquid Pencil, which, while still wet, was wiped across with a paper towel to blend and give an interesting edge to the shapes. Having the option to create large, quick, gestural areas of graphite pencil marks like this is incredibly useful.

Note that Derivan Liquid Pencil is available in six shades of graphite with subtly tinted undertones in a permanent (acrylic) or re-wettable (watercolour) formula. It can be easily thinned with water or acrylic medium, and can be applied with a brush, nib or other art tools. TerraSkin, like tree or fibre paper, will degrade with exposure to heat, ultraviolet light (sunlight) and humidity. Like good-quality archive papers, it is acid-free – important if you wish to store your drawings safely for any length of time.

TWISTING
Medium: Derivan Liquid Pencil

Historical contemporary

MARK TENNANT

These pencil and charcoal head-and-shoulder drawings have a classical or traditional sensibility to them – like historic works. The artist is very much influenced by 19th-century French artists, such as Manet, citing their influence as looking backwards to Old Masters but forwards to now. Tennant encourages others to visit museum collections, making drawings from the works there. His own studies of the work of other artists have led him to adopt some of the poses and techniques found in them. Lighting, positioning and measuring are key aspects.

These drawings are 40 × 50 cm (16 × 20 in). Tennant is aware from the historic works he's studied that drawings can seem too tightly rendered and finished. He strives to make drawings that don't appear as complete, are still open to interpretation. This means his drawings have a contemporary sensibility, too.

As with many of the artist's other works, the looseness of the charcoal belies just how much preparation goes into each one. Tennant sharpens his pencils to needle-sharp points, holding them with thumb and forefinger, and draws with his entire arm. He uses sight-size and comparative measuring techniques with the arm fully extended, too. This means that with every sight measurement taken, the pencil is the same distance from the eye, and consistency results in a well-proportioned pencil line framework. His use of charcoal is a break from precise measurement and rigidity, his chance to 'cut loose a bit' and find a balance away from the purely mechanical.

<div style="text-align:right">

TIM & VADIM
Medium: Pencil, charcoal

</div>

Reportage

KATIE LOUISE TOMLINSON

Tomlinson's drawing is concerned with drawing from life in the hustle and bustle of a marketplace. This kind of in-situ observational drawing work is called reportage. It concerns itself with recording the lives of others. It is a mode of drawing often used in an official capacity. Consider courtroom sketch artists, or government-employed war artists, for instance. A sketchbook is often less obtrusive than a camera in such sensitive situations.

The photographic equivalent of reportage would be documentary photography. Unlike photography, drawn reportage captures minutes and hours, rather than fractions of a second. A reportage artist's job is to edit away extraneous detail, allowing the viewer to focus on the core of activity.

There are things to consider when drawing in a busy environment like this. Looking at the advantages and disadvantages of various media is one, as you'll want to make your drawing kit as compact and manageable as possible. Another factor to consider is where to make your drawing pitch. You'll need a good view-point of what's happening in the situation you've chosen (or been commissioned) to draw. A reconnaissance trip can be useful. It's also worth considering different techniques for drawing people without attracting attention – though my experience is that most people will embrace what you're doing. This is the big difference between drawing and photography.

Tomlinson's approach to this scene has been to use mixed media – pen, acrylic ink, ink wash and Posca pens. She knows that these materials enable her to lay down line and tone with equal speed. Floods of black ink wash – a wet-on-wet technique – make modulated shades, black through grey. Sometimes Tomlinson post-edits her drawings back in her studio, adding flat digital colour in Photoshop.

RIDLEY ROAD MARKET
Medium: Mixed media

A statuesque pose

PHILLIP DVORAK

There are many examples of use of the nude figure in classical sculpture and in architectural detailing. This drawing seems to take something from both. It has a statuesque sensibility about it. We view this figure with an upwards-sweeping motion of our eyes. He seems to stand taller and higher than us – like a statue on a pedestal. The upstretched arm suggests he might be reaching out or supporting something out of the frame. This is reminiscent of figures as sculptural supports or pillars on classically styled buildings. The male version of this is called a telamon, or atlas support. The female version is a caryatid.

Being able to draw, paint or sculpt the human figure used to be considered the height of artistic practice. Historically, to perfect an idealised view of anatomy and proportion, artists often drew from Greek and Roman statues. These days we are much more likely to draw from the actual figure, and not see it as a hallowed activity. Anyone can sign up for local life drawing classes if they wish to. Having said that, if you have access to a sculpture gallery or are in an area where there are significant stately buildings, take note of the figurative sculptures there.

Dvorak has used charcoal on a slightly textured white paper to draft the outline of this asymmetrically placed male nude. He pushed powdered charcoal and pastel around with his fingertips and thumb in a very sculptural way, defining form as he did so. Cool blue tones predominate, but sepia tones add a warmth; after all, this is drawn from a live model.

Note that using ready-ground charcoal powder would make it easier to achieve a similar effect. Brand names like Cretacolor powdered charcoal or powdered graphite, or non-brand generic carbon black powder, are all effective. Pastels can be scraped with a craft knife, or crushed with a pestle and mortar.

UNTITLED (MALE NUDE) 8
Medium: Charcoal, pastel

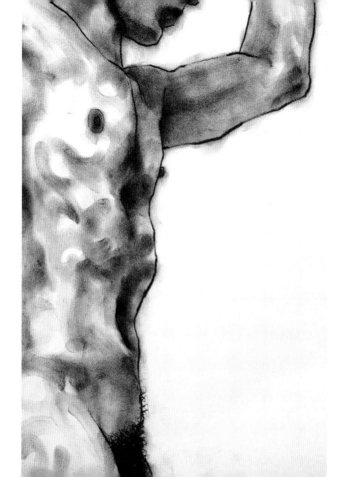

Three-tone sketching

PAUL HEASTON

Quick sketches like this are useful for working things out; they're the visual version of working things out in the margin – say on a maths test paper. Even if the answer is wrong, one gets a better grade because it's obvious that an understanding is there.

In this case, the 'test' was to determine areas of light and dark quickly. The need for speed was partly due to the model's yoga-like stretched pose. This would be a difficult position to maintain for any great length of time. Selecting the right materials for the job in this situation is going to be important, otherwise the moment would be lost.

Toned papers are invaluable when figuring out how to render light values effectively. They establish a mid-tone straight away. (Suggested papers for a similar effect: Bee Paper Bogus Sketch Pad, Rives BFK tan, Strathmore tan toned paper.) Rather than always toning down – adding grey/black, as one does on white paper – a dual approach of both shading up and down is required, leaving one to focus on the highest highlights and darkest shadows. A 4B pencil and white coloured pencil provide those tones/values.

You can see how quickly the model's outline has been drawn. The curve of shoulder, back and outer thigh are a continuous line. Hands and feet are suggested – there is no detail. Internal lines to describe bent torso, ribs and ear have been hastily added. Angled hatching fills in the shadow cast by the bent-over form, though the blackest tone is saved for the shadow cast on the floor. Last of all comes the very lightest tone – white on shoulders, back and upper arms.

STRETCHING FIGURE
Medium: 4B pencil, white coloured pencil

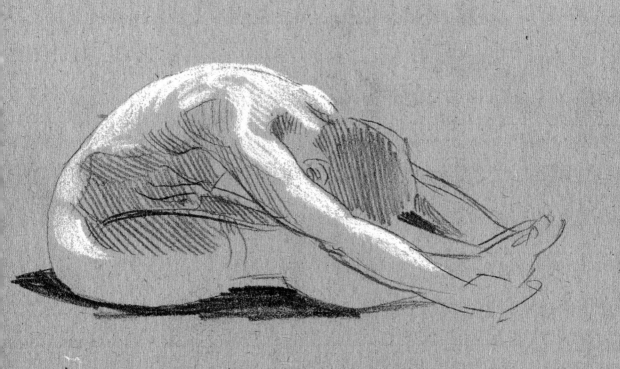

Using studio lighting

MARK TENNANT

When rendering a tonal drawing, the fall of light on the subject is going to be really important. Your source of light can be natural or man-made. It needs to cast a wide range of tone/value from light to dark – especially if your aim is to produce tonal studies like these. Moving your model around to find the best position, and, if using a light, moving that too, will ensure a good set-up to draw from. Tennant favours a light source positioned above, in front and to the side of the model, noting that as 'the sun is above our heads, I exaggerate the lighting for the drama and the effects it creates'.

He begins with a preliminary diagrammatic sketch that helps determine placement and balance. He often draws it in a corner of the paper, leaving a trace of his process. These sketches, as well as the initial outlines of the figure drawing proper, are drawn in pencil.

Shadow shapes are carefully measured and outlined in charcoal, and massed in with willow/vine charcoal. The lighting allows Tennant to locate them as it provides good contrast between areas of light and dark. The powdery quality of the broadly applied charcoal means that it can be shifted, modified and worked back into. The artist takes off the excess with the back of his hand, working back into it using 2B pencil. Then, if too much is taken off, he goes back in with the willow charcoal. Evidence of these modifications can be seen in both of these drawings.

LILIYA & CLAUDIA
Medium: Pencil, charcoal

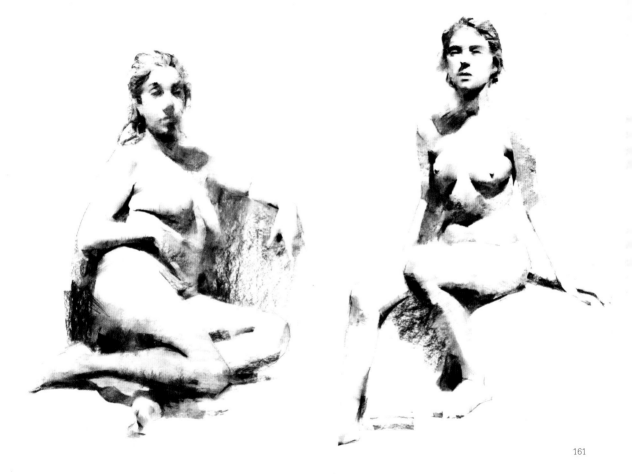

Advancing colour

HARRY ALLY

It can be very daunting to start a drawing on a stark, clean, unmarked piece of paper. Consider pre-preparing several sheets of paper with scribbles, stains or portions of colour. Having a collection of these papers ready and waiting can be really useful. Choosing a sheet with marks already randomly placed but suggestive as to where to start your drawing, or how to handle a composition, is a great help.

The emphasis of this drawing is predominantly vertical. The orange scribble on the model's right shoulder is, too. The model sits upright, looking at us with her hand across her face and her knee pulled up before her. The diagonal it forms leads our eye to the lower left-hand area, where the foot points us to the corner, but those hot, advancing colours bring us back up the drawing to her shadowed eyes.

Don't think that detail in a drawing is what necessarily makes it work. Don't get stuck on detail. Many do, especially on facial features and hands. The abstract

pastel work and charcoal looseness are intrinsic to the success of this drawing. The charcoal isn't handled tightly. Careful observation of outline, edge and tonal play has given the artist the confidence to seem almost casual in how he draws. This takes much practice.

When used in a drawing, advancing colours like red and orange will stand out. They are the attention-grabbing colours of the spectrum.

FIGURE STUDY #4
Medium: Charcoal, pastel

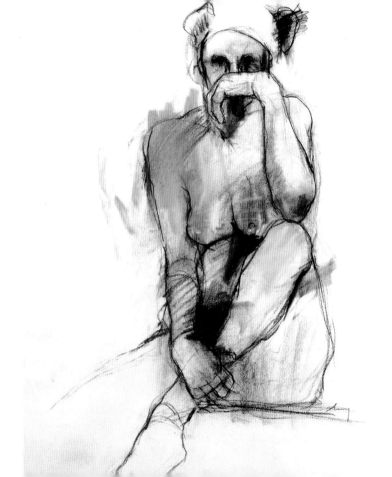

iPad drawing

CYNTHIA WICK

Here, the artist has sourced an old family photograph as the basis for her iPad drawing. The subject has been captured in that classic mode of holiday snaps – looking directly at us, comfortable on a sun lounger. The slightly awkward composition of the original photo actually makes for a more interesting drawing. The sitter isn't centred in the frame; the emphasis of the composition is shifted to the right, her brightly patterned dress flowing towards the corner. Full sunlight eliminates most of the shadows. Everything is high key – light and bright.

The illuminated screen of a tablet or smartphone is ideal for blocking in and editing swathes of flat colour. The skin of the subject's face, shoulders, chest and arms is pretty much one consistent tone. The yellow of her dress would have been quickly filled in, flowers added later. Tablet drawing allows an endless playful combining and layering of colours one couldn't manage on paper – i.e., light over dark – without everything getting muddied.

The success of this drawing is that Wick hasn't tried to tidy things up too much. With a pinch action on the screen surface, it's simple enough to zoom in on an image and add detail. Lilac tones pick out a little shadow under the chin. Pink and pale blue pick out cheeks, lips and eye shadow, capturing the look of a bygone era.

A useful feature of the Brushes app is that it allows you to review the creation of your drawings. It records each stroke you make as you go along, enabling you to play back exactly how you created each work. A drawing performance such as that would suit this image.

MRS COLE
Medium: iPad

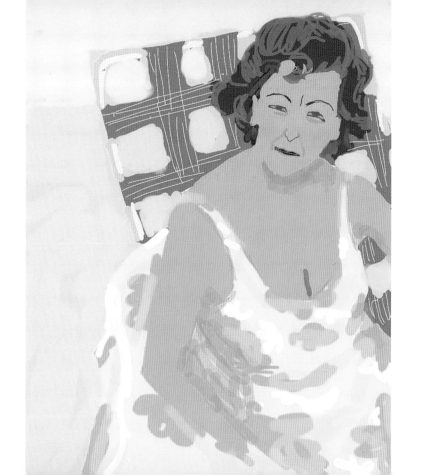

Warm and cool colours

Here we see a dynamic, experimental take on the classic head-and-shoulders portrait. Multiple layers of various media have been built up. They include Conté and pastel (dry media), ink and gouache (wet media). It would be most usual to use dry media to draft out an image and then use wet media later as a top layer. Horst has mixed the order of things up. He doesn't see the application of drawing media as a fixed thing but instead as a malleable set of substances that can be shifted around. He'll render an image accurately but not dwell too long on retaining a realist rendition, believing that we don't see things in a crisp, 'hyper-static state', but rather as motion, distortion and fragments. He tries to take things away – to eliminate details. This is very much the visual language of painting, but here rendered as a drawing.

This multimedia piece works pictorially because of Horst's understanding of tone/value. Light and dark modulations are used in the right places. The light source comes from the right, therefore the paler, or tinted, colours are on that side. The darker, or shaded, colours are further from the light – they signify the shadows. Interestingly, the artist also plays with hot and cold colour theory – the warm colours of red are those most brightly lit, while the shadows are cast in cool blues.

Horst's final act of 'destruction' was to drag his hand through his work. His theory works. That smeared arc pulls in any isolated parts as a result of its blending of colour and media, and brings a movement and vitality to the drawing.

ONE OF THESE MORNINGS NO. 1
Medium: Ink, Conté, gouache, pastel

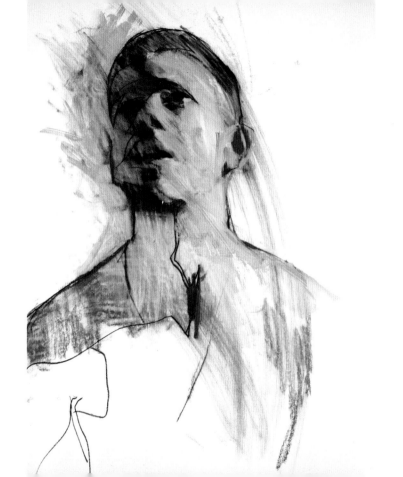

Block colour

This portrait of a young girl sitting on a sofa fills the broad space of a landscape format piece of paper. The artist has taken a lead from her posture as she leans comfortably on the arm of the sofa, placing her to the right-hand side of the space. This is unusual. An asymmetric, or off-centre, bias to a drawing can make a drawing more dynamic.

One can see the decisions the artist has made to construct this drawing. Loose, sweeping pencil marks, robustly applied charcoal and bright pink acrylic paint have been used in combination to construct this lively work. The artist has used sweeping physical movement, drawing from the shoulder rather than the wrist. The materials have been held in a relaxed manner, not tightly gripped. This approach to drawing is much easier to achieve at an easel. Standing to draw means you can frequently stand back from your work and be more physically at ease.

The drawing makes use of diverse mark-making. Pencil line indicates edges. Pink acrylic paint has been broadly applied on all but the exposed flesh of arms and face. Some has been diluted, and with brush and fingertip used to indicate shadows on the girl's arms. It picks out her lips and a little colour on her cheek, too. Once the paint has dried, some more pencil lines have defined the break between furniture and girl, and the details of her face and hair.

Charcoal has been used as a black swirling mass on the girl's leg in the foreground, and as a smudged tone for her hair and face. It has been modified with an eraser, using a technique called reverse drawing, where the eraser is used to remove the charcoal, here creating strands of hair, and highlights on the girl's face.

RÉKA
Medium: Pencil, charcoal, acrylic

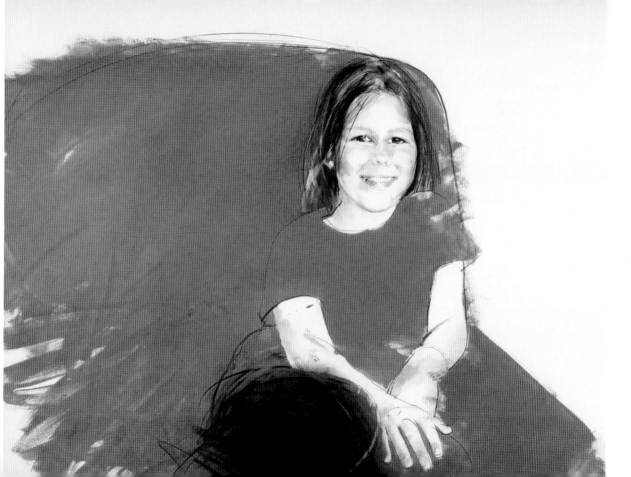

Planar perspective

. DWAYNE BELL

This artist uses a familiar and favourite vantage point in this colourful drawing. Bell has fondly titled it 'Down the Front Club 2'. As with his other drawings, we get a real sense of the space these anonymous bus travellers temporarily inhabit. Some of this is because of how Bell has depicted that space. He uses a basic premise of perspective drawing: things further away are smaller; things nearer to us are larger. More specifically, Bell uses planar perspective. This composition is divided into a series of layered planes to create a sense of depth – partial heads in the foreground, vertical safety handles in the middle ground, and those 'down the front' of the bus in the background.

This drawing is from Bell's bus series. He uses his travels to explore a variety of drawing approaches, though for him everything starts with pen and paper. Many of his drawings are left as they were when they were initially created (see page 67), while others have watercolour and crayon added to them. Sometimes he'll photograph his sketchbook and then add colour using the Procreate app on his iPad. He often notes down important colours around his drawings, especially if he thinks 'follow-up' work like this is likely to happen.

This is one of his augmented iPad drawings. It utilises and layers all of his drawing methods. The post-editing of the drawing has enriched, replaced and enhanced its framing, colours and textures. A linear sketchbook work completed in situ has been transformed.

DOWN THE FRONT CLUB 2
Medium: Fineliner pen, Indian ink, digital

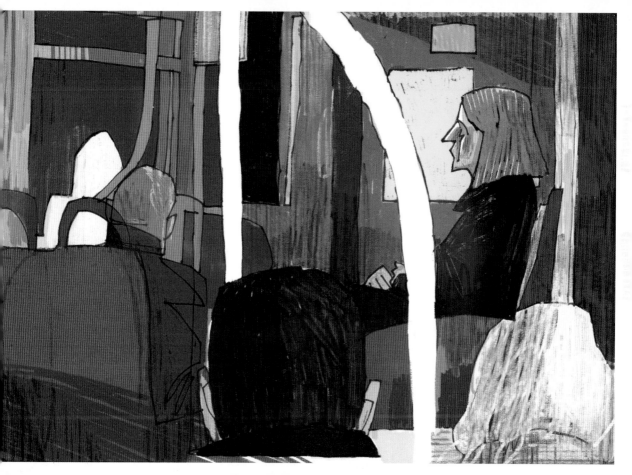

Digital sketchbook

CYNTHIA WICK

This is another example of drawing from the figure when the opportunity arises. Nothing is arranged – no formal planning has taken place. The artist's mother-in-law took a nap on a lounger by a lake. While she rested, an iPad was used to capture her in repose.

It's important to include and consider smartphones and tablets as part of our drawing equipment, because they're so effective at allowing us to draw on the move. There are many apps on the market that are excellent for sketching, layering, manipulating and amending our drawings. This drawing was created using the Brushes app. Apps like this provide easy-to-use access to an extensive palette that can be manipulated in terms of opacity (transparency) and the blending and mixing of your own colours. The speed with which it allows you to pick up colour and draw is apparent in the drawing. It would be unusual for a rapid drawing on paper to contain as many different colours as we see here.

The same toolbar allows quick use and manipulation of various drawing materials, or 'brushes', too. The artist drew this with her fingertips directly on the iPad screen, using a variety of brush settings to change line width. She prefers this method to using a stylus, finding the approach more responsive to her touch and therefore better for producing work spontaneously and intuitively.

Consider using a digital platform as an extra, or perhaps as your main, sketchbook. Remember to take into account that this is illuminated, i.e., light-based colour, as opposed to pigment-based colour. If you print your screen drawings, you may find that the colours aren't as 'true'.

THE LAKE
Medium: iPad

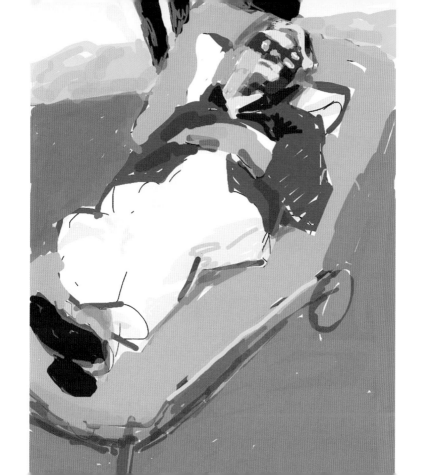

Coloured pencil portrait

AGATA MARSZALEK

This portrait of a young girl is rendered on a plain cream paper. This lends warmth to the image from the get-go, and is sympathetic as a skin tone. Marszalek has used both graphite and coloured pencil to draw her model. To begin with, very light graphite pencil guidelines mapped out the composition. The sitter was placed so as to fill the central panel of the paper. The drawing has a symmetrical balance.

The gaps between her shoulders, the top of her head and the paper edge are about equal. The space at the lower edge of the page is wider. As a general rule, it's best to add a bit more space to the bottom border than the other three sides. This helps to overcome a slight optical illusion. When a border is the same width on all four sides, the image tends to look slightly closer to the bottom. Bottom weighting compensates for this illusion.

Once the placement of the girl was decided upon, graphite pencil was used to strengthen the main outlines. Their subtle grey is a perfect tone – black line would be too harsh. The darkest tones are reserved instead for eyelashes, the pupils of her eyes and the lowlights or shadows of her hair. Colour is subtly handled in this drawing, too. The loose mark-making of the T-shirt consists of a blend of pink and mauve, the sitter's hair consists of two browns. Both areas have a grainy finish because of the paper's tooth (or texture). Warm tones combine in the minimal shading around the nose and eyes. Only the lips are a single colour.

There is no doubt that the artist's combination of materials, composition, technique and colour makes this a successful drawing. The person being portrayed can define a drawing's success, too.

UNTITLED
Medium: Coloured pencil, pencil

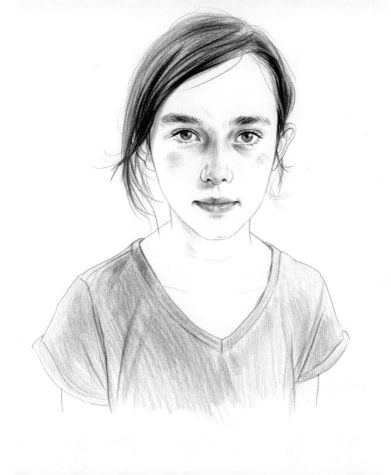

Heightened colour

MARÍA CEREZO

This drawing is one of a series of self-portraits called 'I just don't know what to do with myself'. The artist has chosen to draw her face and shoulders in monochrome – varying tones of one colour. She's chosen to use a vivid and intense red, one that is not true to the actual skin colour but is true to its tonal values – modulations of light and dark. As an advancing colour, we always notice red first. By using it here, our attention is drawn to the artist's face and shoulders. The pencil crayon work on the face is smoothly blended. On the shoulder it forms a swirling pattern. Using pencil crayon on a ribbed paper provides an interesting textured effect, too.

There's something unusual about the way the face is drawn. There's a white space between it and the hair. The face seems mask-like, as if it has been drafted into a place it doesn't quite belong. This probably relates to the title of the piece; not knowing what to do with herself, the artist is considering putting a temporary

and changeable face towards the world. We see her downcast; a tear escapes her closed eye. It's green. This is the best colour to choose to help us notice this small detail. Green is the complementary or opposite to red on the colour wheel. It's the colour that shows up the most against red.

These subtleties are topped by a dramatic and more loosely drawn hairstyle. The artist has used a dip pen and black ink. Though looser in style, the hair is no less well observed. Cerezo has carefully looked at the natural fall of the hair and the patterns it makes. The intensely dark black segues into dyed ends of green, blue, orange and mauve.

YOURS ('I JUST DON'T KNOW WHAT TO DO WITH MYSELF' SERIES)
Medium: Mixed media

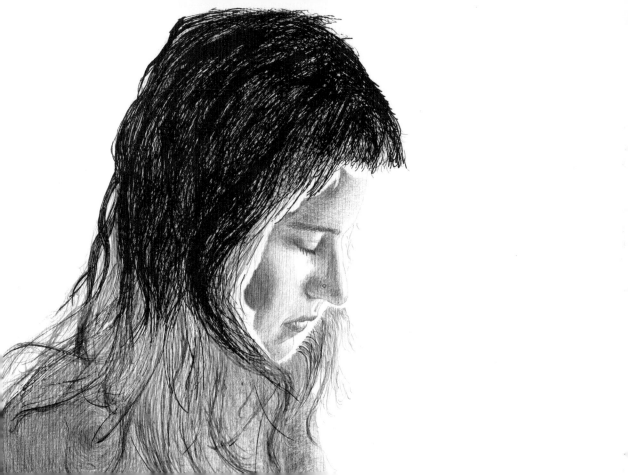

A drawn painting

MARK HORST

Like many artists featured in this book, Horst is primarily a painter, and like them his drawings often inform his paintings as sketches and smaller mock-ups. Unlike many of them, he draws back into his paintings. They become a visible part of the piece rather than a 'lost' under-drawing.

This combination of drawing and painting is rendered on gesso. This is usually white and is painted onto a surface – here hardboard – to seal or prime it, creating a smooth, absorbent surface. This has allowed the paint and charcoal to adhere to the hardboard more readily.

Horst has used a muted colour palette of olive green and a mustard yellow to block in the main shapes of a sitter on an armchair. This is essentially a portrait, but the sitter is arranged in a much more informal pose than we might expect. The arrangement creates a strong diagonal form from top right to bottom left. She sits with hand on head, looking as though she's patiently waiting

for Horst to finish what he's doing. The pose seems much more informal than many of the others in this book set up and drawn in life drawing rooms.

The blocked-in forms of oil paint take a long time to dry. They don't become touch-dry for at least forty-eight hours. This means that Horst's charcoal work doesn't just sit on the surface; he can literally draw into the paint. It's not a conventional technique, and it is messy, but it befits his interest in layers of observation, construction and destruction.

WOMAN WITH HEAD TO HAND
Medium: Oil paint, charcoal

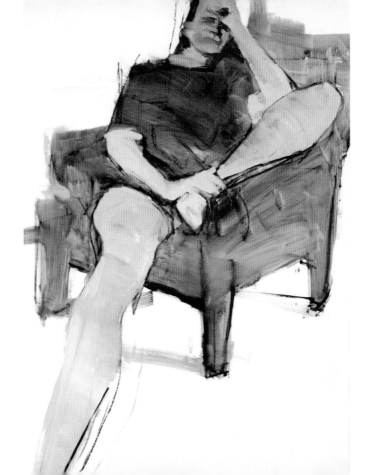

Thread lines

At first glance this image could be a pen drawing. However, there is an alternative, and innovative, technique at play. This urban scene, of a man on a mobile phone, is drawn using pins and thread. What you see is the outcome of a sequence of processes, all drawing-based.

This is a detail from a much larger thread-drawing installation. This portion alone measures approximately 100 × 200 cm (40 × 80 in). The large scale suits Smyth's subject matter – a busy cityscape, with lots of architectural detail and lots of people.

Smyth's work is often based on individual experiences – ordinary nuances of the everyday. She uses her camera when out and about to quickly capture those moments. The photographs are used to make drawings in the studio. These in turn are projected onto the wall to make a composite image that fits the installation/exhibition space. Pins are hammered in at strategic parts of the projected images. These form the plot points – the bare bones of the drawing – between which thread is joined, wrapped, twisted, knotted and tangled until the composite image fits the space.

Inorganic or man-made/architectural linear forms are drawn using tautly pulled thread – reminiscent of dot-to-dot drawings. Organic/figure work utilises many more pins, around and between which threads and knots are exaggerated to build up the outline. The floating ends of the thread mean that the drawing maintains a textile-like, embroidered characteristic. Smyth's innovative take on drawing, which blurs the boundaries between fine art drawings and textile art, flat and 3D work, illustration and embroidery, has meant she has received many large-scale commissions. These include works for Adidas, Hermès, Mercedes-Benz, the *New York Times* and the Hamburg Philharmonic.

THREADBARE (DETAIL)
Medium: Pins, thread

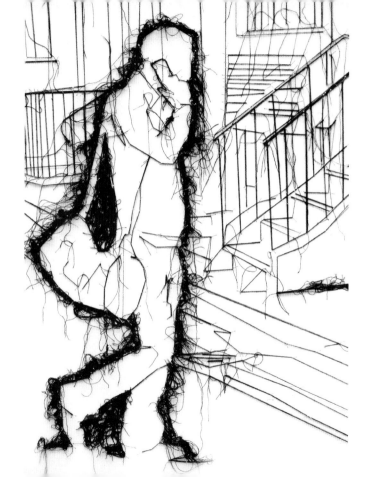

Figure work as illustration

DENISE NESTOR

This image was used as the front cover of a book of poetry. The poetry collection has been described as 'like entering into a dream' and 'a study in dislocation'. It is immediately apparent that this complex, layered drawing is suitable for the cover. It is constructed of two separate views. One portrait – using line – is drawn side on (or in side profile); the other is three-quarters on, and more tonal. Their layering means that it's challenging to get a visual hold on one point of view or the other. One's gaze constantly shifts between points, using the position of the person's eyes to try to make sense of things.

Just as it's difficult to view this work, it would also be difficult to draw it without some kind of planning or forethought. One approach might be to complete two separate drawings and combine them using digital means – layering them with a program like Photoshop. Another approach might be to draw on tracing paper. Its translucence is excellent for figuring out where

best to place things – moving your drawings around until they sit together well.

The most obvious post-editing in this image are the white shapes at the top and bottom. In keeping with the drawing's title ('Lepus', as in 'hare'), Adobe Illustrator has been used to add in the outline of some ears that fit both heads simultaneously.

If you aim to complete as complex a drawing as this, consider adding the coloured background last through digital means. You can then experiment with any original components of a composite work like this – on white paper – even more at a later stage. Tracing paper is available in different colours and weights, while Illustrator is a vector-based program, and vector shapes are re-scalable digital graphic objects that lose none of their smooth-edged quality when their size is changed.

LEPUS
Medium: Pencil, digital

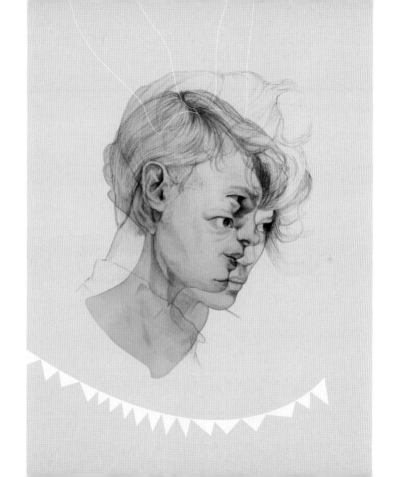

A sketchbook habit

DWAYNE BELL

A sketchbook filled regularly and methodically fills quickly. You're more likely to succeed in doing so if you choose a project that motivates you and equipment that you enjoy using. Quality and consistency are key. Make it a habit to regularly visit your art supply shop; chat with the staff, experiment with the samples on show. A good specialist art shop will have staff who want to engage with you. Many of the people there will have been art trained.

Bell uses a Leuchtturm 1917 A5 sketchbook, which is very similar to the Moleskine sketchbook. It too has a hard cover and opens flat so you can work across both pages easily. The difference with this sketchbook is that it contains brilliant white paper (rather than cream). Bell uses a Kaweco Sport Classic or Lamy fountain pen. Both of these nib pens deliver a smooth, consistent line. He colours the drawings later with various media, including Winsor and Newton inks and an iPad.

Bell settled into his own project – drawing fellow travellers every day – fairly quickly, tuning out the world and focusing completely on the page and the line, using the time as a buffer between a busy day at work and home. Asked if the subjects he draws get annoyed, he replies, 'I try to be discreet. I'm on the same bus every day and most of the other passengers are, too. I think I've just become an accepted part of a journey.'

Bell posts his bus drawings daily on Instagram. Every six months he reviews his sketchbooks and prints a 'Bus Book' of the best bits, selling the publication online via social media.

ADAM'S APPLE
Medium: Pen, digital

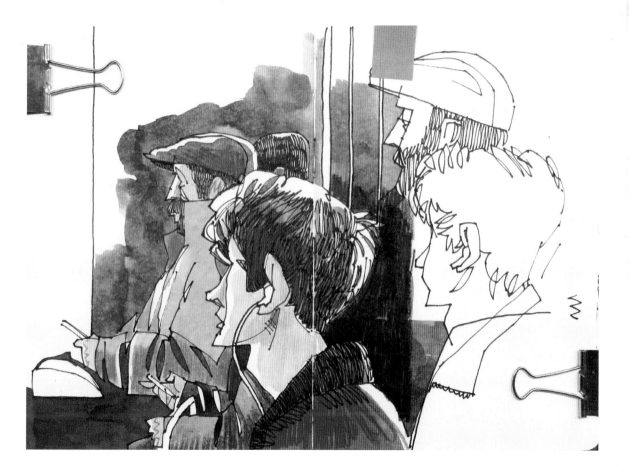

Enhancing a sketch

JYLIAN GUSTLIN

This multimedia drawing contains many components – traditional techniques one would expect to find in the life drawing room, and post-editing Photoshop work that enhances that earlier observed drawing.

Holding a pose with an arm stretched above the head is difficult to do. Capturing the moment the model was in this pose has influenced the drawing. The primary source line drawing of the model was executed fairly rapidly. The pencil hasn't left the paper. Its continuous contact with the paper surface is a visualisation of the artist's eyes tracing the contours suggested by the model's shape. Sometimes the line comes back on itself – look at the looping line at the navel and small of back, and the half loop between breast and back.

Drawings like this are often completed as warm-up exercises, or used to capture more animated model stances. They can be challenging to do, as they force the artist to be brave, to experiment and to recognise that things might go 'wrong', and that that's OK.

What's unusual about this quickly executed drawing is how its basic premise has become something much more complex through Photoshop alterations. Its pencil lines mean it retains a drawing language, but overall it seems much more painterly. The surface seems to reveal hidden marks, motifs and textures. Scanned-in layers from other sources, drawings, photos, mark-making experiments and paintings have been coupled with the original drawing. That fluorescent yellow/lime-green band sectioning off the lower third of the image completes the work, adding an exciting and yet sensitive flourish of colour.

DRAWING 2
Medium: Coloured pencil, pastel, paint, digital

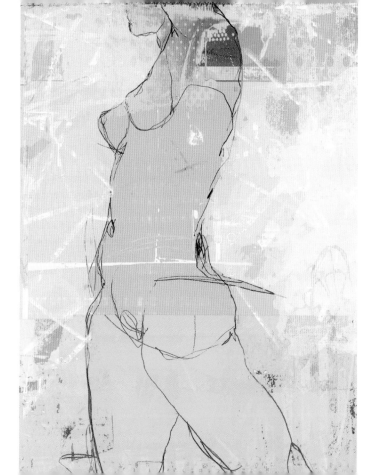

187

A new viewpoint

MIRCO MARCACCI

When I first saw this image it was in greyscale – black and white. It was a surprise to find that the original was a predominantly red one. Both are included here so you can compare them.

As with other drawings in the book, this is a self-portrait. The difference here is that the artist is not looking out of the drawing at us. He has not observed himself in a mirror. His gaze, and ours, is from above.

Thinking of different ways to facilitate drawing ourselves is worthwhile. Using a mirror is one, and perhaps the most obvious. It is, of course, 'from life', but the image we draw will be a reversal of our true selves. Another method is to take a photograph. However, the problem with only ever drawing from photographs is that you're not observing form in 3D. The image is already flattened into 2D. It can no longer be described as truly 'from life'. Another idea is to set up a camera, but view what it sees on a connected monitor – like looking at yourself in strategically placed mirrors in a waiting room; seeing yourself from unexpected, and new, viewpoints.

This artist has used himself as the model specifically to study the human body. He is not particularly interested in facial likeness. The drawing is from an interesting angle – from above, and from the top of the head down, left hip pushed to one side. Head, body and legs form a zigzag of sorts. This is echoed by what seem like patterned markings on the torso. In red, these seem much more significant, almost graffiti- or tribal-like in their patterning.

REDSELF 06, REDSELF BLACK AND WHITE
Medium: Fineliner pen, Indian ink

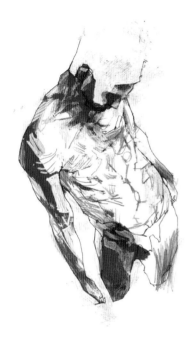

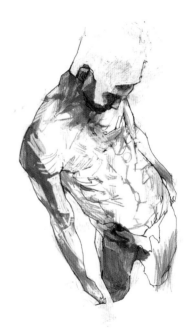

Enhancements

HARRY ALLY

The placement of this young female model against the right-hand edge of the paper makes the paper edge seem like the support for her back. This is compositionally very clever. Others drawing the same pose would probably place her centrally on the paper. Her languidly placed arm takes centre stage, but the model's facial features, seen in profile as she gazes ahead, take our attention. Then we notice her horns; she simultaneously has human and non-human traits.

Human hybrids, mythological creatures and shape-shifting narratives have long been a device used in depicting the human form. (See also Denise Nestor's 'Lepus' on page 183.) Motifs like this appear across many cultures. The red pastel used on the woman's face is reminiscent of ceremonial paint – a mask to hide one's identity, or perhaps to obtain power from the creature or spirit being represented.

These things aside, this is essentially an observed life drawing drawn predominantly using charcoal. The model is in a fairly relaxed pose with her right elbow propped on a ledge. The support (like the model's back on the paper edge) is only suggested, not actually drawn. The light source comes from above and slightly behind the model. We can surmise this from the shadows cast. Charcoal is a good medium for easily modulating tone like this.

The artist has modified the surface with the addition of taped-in collage and white acrylic paint. Both of these methods can be used to cover up or modify mis-drawings. The acrylic provides a starker white than the warm tone of the paper, bringing out the highlights of the horns, shoulder and the suggestion of a sleeve. (For painting combined with drawing, see also Endre Penovác on page 169, and Jylian Gustlin on page 187.)

WOMAN WITH PINK FACE AND HORNS
Medium: Charcoal, pastel, acrylic, tape

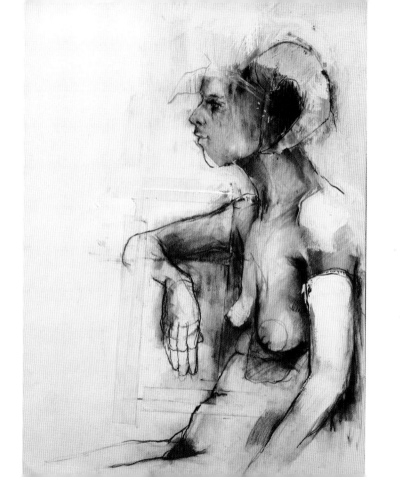

Utilising influences

HELENA PEREZ GARCIA

We see a female figure, eyes closed, apparently sleeping. There's something peculiar about her pose. Her legs seem slightly askew. The hand on her hip looks slightly awkward. She appears mannequin-like. Look at her face. It has doll-like rounds of pink for cheeks.

Garcia has constructed this figure in repose from multiple sources – many things inspire her – including Roman antiquities, mosaic floors, medieval painting, Byzantine art, classical statues, decorative wooden panels, frescoes and even old black-and-white films. Featuring these influences on her blog enables the artist to share some of her creative process with us.

Garcia has not made this sketch for a given brief, i.e., for a client. She describes it as personal work. It's an experimental piece. The meaning of 'sketch' is: a rough or unfinished drawing that is often made to assist in the making of a more finished work. Garcia has roughed out an idea in pencil. She is mindful of her influences. Flattening of form is one of them. The angle of the legs

now makes sense. The figure's rosy cheeks and her elongated hand can be sourced from her inspiration collection, too.

Garcia has combined historical and contemporary influences in this image. She clothes her model using digital means, making her appear more like a magazine fashion model of today than a figure of times past.

UNTITLED 2
Medium: Pencil, digital

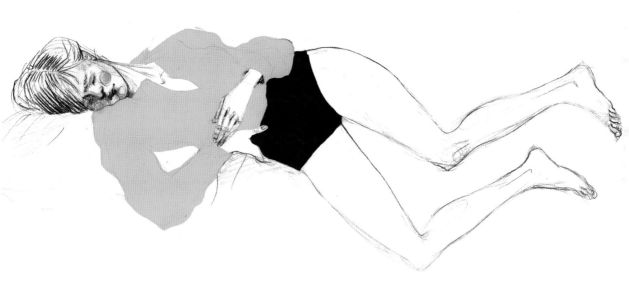

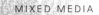

Wet media

ROBERT SCHOLTEN

When other passengers are using their journey time on electronic devices, their attention is elsewhere. This makes them ideal candidates for your drawing observations. There are several examples of moments like this in this book. This one is a little more complex, in that the artist is using water-based ink and paint while on the move. A little more preparation is needed if you likewise intend to use wet materials.

A sketchbook, pencil, drawing pen and eraser are good to have as constant companions. They might even be specifically marked as travel journal items. Setting yourself a project to use them whenever you travel – on the journey itself as well as at the destination – is a good habit to get into. Such drawings often have more life and atmosphere, as opposed to artwork done from pictures. Don't be put off by cramped conditions. 'Pull-down trays' on the back of train/plane seats, your lap or a hardback sketchbook can often be enough support.

Here, the overall scene has been preliminarily laid out in pencil across the double-page spread of a sketchbook before being inked up. You could carry a small vessel of ink, dipping into it with a nib pen and brush. You might also consider a brush pen. The latter is not as long-lasting but offers great (non-spilling) portability.

Line thicknesses alter throughout this travel drawing. The occasional jolt of the train and limited space will have affected application, as will deft use of the brush tip, its side and the amount of ink the brush contains. The turquoise livery has been blocked in with opaque gouache paint. The pattern on the fabric in the fore-ground has been created with some twists and dabs of the brush.

PASSENGERS ON THE TRAIN
Medium: Ink

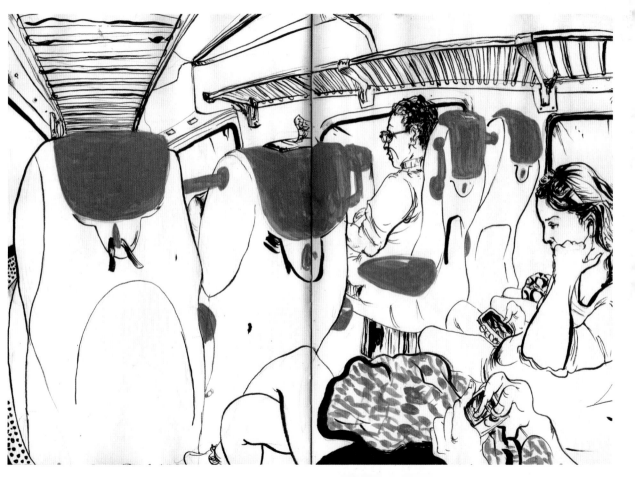

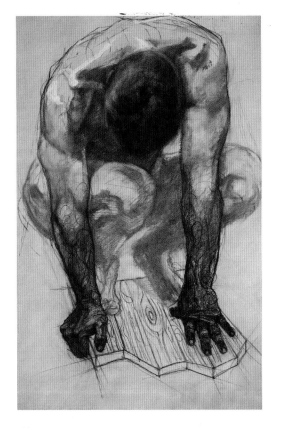

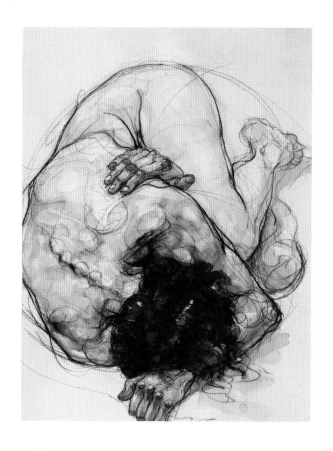

Fundamentals

SYLVIE GUILLOT
Left to right: **TENSION 2 – MICHEL, TENSION 5 – MICHEL**
Medium: Charcoal, pastels, black Conté pencil
EMMANUELLE HUDDLED UP
Medium: Watercolour, black Conté pencil

MATERIALS – TO DRAW WITH

A **pencil** lead is made of graphite and clay. The balance of these ingredients determines its hardness or softness. The grade you select will affect your drawings' outcome. I recommend 2B through 10B. Anything harder (HB through 10H) is difficult to erase without leaving indents on the paper, and is less sensitive to mark-making pressure and therefore tonal range. Pure **graphite sticks** and blocks are similar to pencils, but not encased in wood. Some are paper-wrapped or fit into holders. They give wider strokes than standard pencils, so are good for larger-scale work. They come in a smaller tonal range than pencils: normally HB, 2B, 4B and 6B. **Graphitone** is a water-soluble version of the medium. **Propelling/mechanical** and **clutch pencils** all hold leads in an outer casing. Their advantages are: no need to sharpen, consistent line, refillable, retractable tip and built-in eraser. This makes them perfect on the move.

Charcoal is one of the mainstays of the life drawing room. It's available in two main varieties – vine (also known as willow) and compressed. (Pencil charcoal is also available for details.) Vine charcoal makes a lighter mark, smudges easily and can be rubbed or erased away easily. It is usually purchased as a bundle of irregularly shaped sticks. Compressed charcoal is powdered charcoal that has been reconstituted with a binder. It gives a much deeper black and is difficult to remove with an eraser. Charcoal drawings are often very dusty. They will need fixing.

Coloured pencils vary a lot in quality. Unlike graphite and charcoal pencils, their 'leads' are wax- or oil-based and contain varying proportions of pigments and binding agents. Water-soluble versions are available.

For richer, darker blacks, use a **carbon pencil**. They are softer than graphite, and harder than charcoal. Because of their softness, you'll need to be careful when sharpening them. I recommend using a craft knife.

Pastels are available in several types: hard, soft, oil and pastel pencils. Pastel sticks or crayons are pure powdered pigment mixed with a binder. Their colours are bright and can be easily smudged and blended (don't overdo the smudging – it's easy to muddy their colours). They work well on dark and textured papers. Oil pastels are more buttery and don't need fixing.

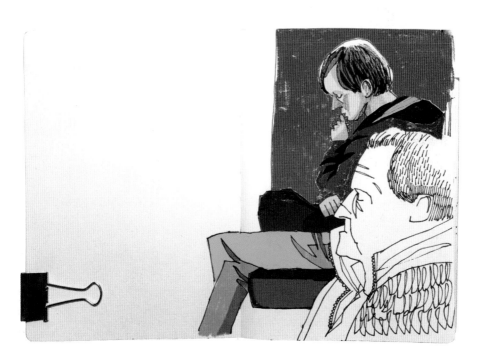

DWAYNE BELL
DOWN THE FRONT CLUB 2
Medium: Pen, digital

Conté crayons (hard pastels) are square drawing sticks, harder than charcoal and most commonly used in black, white and sanguine (earth red) tones. Use their tip or whole side to draw with. They're effective on textured and toned surfaces as well as smooth, white paper.

Erasers are as important for drawing with as they are for removing unwanted marks. A good eraser should lift graphite with the lightest of touches without smearing. It should leave paper undamaged, and not leave too much residual mess. Soft, malleable kneaded/putty erasers are better with charcoal; they allow you to erase back to the paper, regaining highlights without smudging. Precision or electric erasers are useful for more illustrative, design-oriented work.

Ink provides strong line and colour. It can be water-soluble or permanent, and applied with brush, brush pen, dip pen, fountain pen, felt-tip or drawing pen. What you choose will depend on the mark-making outcomes you wish to achieve and the permanence of the ink – either for exhibition purposes, or to combine with other media.

Colour

Monochrome or limited colour tends to dominate in drawing from life. Getting to grips with the range of tones and different types of lines is generally already enough of a challenge. To begin with, limit its use. Try colour for high/lowlights only; choose a few related colours – earth tones, for instance; or perhaps select colours that you think best describe the 'mood'.

Test your materials in good light before narrowing down your colour selection. For example, artificial lighting in a life drawing class might not let you see the true colour of your materials. Try your colours on white and coloured paper. Consider annotating your drawing, adding colour at a later stage with watercolour, acrylic or gouache.

It's important to include **digital** and post-editing of drawing here, too. Various drawing apps are readily available. The convenience of working on a smartphone or tablet ensures you can draw pretty much anywhere, anytime. Post-editing on phone/tablet or in Photoshop/Illustrator provides yet more possibilities.

Other drawing equipment

Craft knife – for sharpening pencils (I don't recommend using a pencil sharpener), shaving charcoal and pastel, and trimming/cutting paper.

Masking tape – available in a variety of widths, easy to

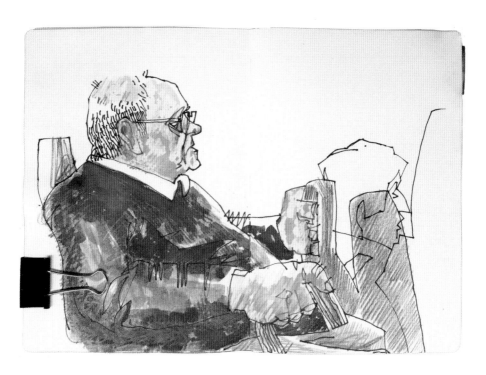

DWAYNE BELL
MR BELL
Medium: Pen, watercolour, coloured pencil

tear; take off the excess tackiness of the glue on your hand or the fabric of your clothes so it doesn't damage your paper when removed.

Board clips – good for holding down paper.

Paper stump – for blending charcoal and chalk pastel.

Sandpaper – for shaping of pencils, graphite, and Conté points and edges.

Fixative – to preserve drawings likely to smudge: pastel, charcoal or chalk.

Camera/video/smartphone/tablet – for research, compositional experimentation, record of movement. Use them in public – preferably with consent – never in a life drawing class.

MATERIALS – TO DRAW ON

Paper for the life room or drawing studio will generally be larger than that used in less formal situations. Life drawing spaces are set out specifically for observing the human form, so are usually equipped with specific items that allow large-scale drawing. A good support (paper) to use there is **cartridge paper** – 96 to 220 gsm. A plentiful supply of cheaper **newsprint** is good for newcomers to life drawing classes.

You'll inevitably choose your paper, for whatever location you choose to draw in, because of its size, surface texture, weight, tone/colour and longevity for exhibition purposes. Think about the effect you want to create. A good rule of thumb is the finer the media, the less paper texture is needed.

Papers to consider

Pastel paper – toothy, dimpled and Ingres.

Rolls of paper – if you wish to work larger.

Tracing paper – for layering, toning things down, as well as tracing.

Collage materials – washi tape, found paper, glue stick.

Acid-free/rag/archive-quality sketchbooks – landcape/portrait formats, binding styles, size; whether for travel or studio-based drawing.

STUDIO/SPECIALIST EQUIPMENT

Easels – standing/sitting.

Drawing boards – various sizes, though generally slightly larger than A1.

Lighting – directional spotlights.

Storage drawers/plan chests – for keeping large-scale drawings flat and clean.

Further reading

The figure

Ball, E. (2009) *Drawing and Painting People: A Fresh Approach*. Marlborough, United Kingdom: The Crowood Press.

Malbert, R. (2015) *Drawing People: The Human Figure in Contemporary Art*. London: Thames & Hudson.

Simblet, S., J. Davis and J. Davies (2001) *Anatomy for the Artist*. London: Dorling Kindersley Publishers.

Stanyer, P. and T. Rosenberg (1996) *Art School: Life Drawing from First Principles*. London: Arcturus Publishing.

General (with figure/media specific sections)

Birch, H. (2013) *Freehand: Sketching Tips and Tricks Drawn from Art*. San Francisco: Chronicle Books.

Brereton, R. (2009) *Sketchbooks: The Hidden Art of Designers, Illustrators and Creatives*. London: Laurence King Publishing.

Hobbs, J. (2016) *Pen & Ink*. London: Frances Lincoln Publishers.

Ibarra, A. and M. Valli (2013) *Walk the Line: The Art of Drawing*. London: Laurence King Publishing.

Kovats, T. (ed.) (2006) *The Drawing Book – A Survey of Drawing: The Primary Means of Expression*. London: Black Dog Publishing.

Lawlor, V. (2011) *One Drawing a Day: A 6-Week Course Exploring Creativity with Illustration and Mixed Media*. Beverly, Massachusetts: Quarry Books.

Maslen, M. and J. Southern (2011) *The Drawing Projects: An Exploration of the Language of Drawing*. London: Black Dog Publishing.

Artist index

Index

Acknowledgements

Many thanks are due to all of the artists and illustrators who have so kindly allowed me to use their drawing works in this book, and to the RotoVision team for bringing it all together.

Special thanks to Liz, Jonathan and Lisa for their encouragement, and to Ann and Andy for helping me figure things out.